THE

Rainbow

IN YOUR LIFE

A complete Guide and Workbook on How Color Empowers Your Life and Dreams

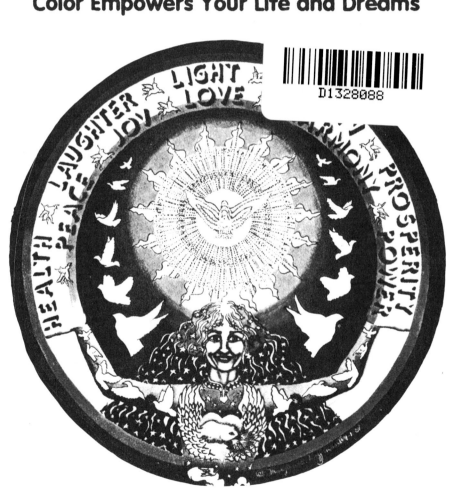

Second Edition

Maryanne E. Hoffman

Third paperbound printing
First Edition published, August 1987
Second Edition published, August 1993

The author expresses a special heartfelt thanks to her brother, Richard Rule-Hoffman for his continual support, assistance and encouragement for this second edition. Also a warm appreciation and thanks to Frank Sovec and Hurley J. Quackenbush.

The Rainbow In Your Life
Copyright © 1987, 1993 by Maryanne Hoffman

Star Vision's, Publisher
P.O. Box 39683
Solon, Ohio 44139

Author photo by John Barr, *USA Today*
Cover and interior illustrations by Maryanne Hoffman
Copyright © 1985, *Mystical Messages*; Color Card, greeting card line.

Library of Congress Cataloging-in-Publication Data

Hoffman, Maryanne
 The Rainbow In Your Life

 1. Psychology, Color Therapy. 2. Art Therapy
3. Holistic Health 4. Occult Sciences I. Title
II. Rainbow In Your Life

ISBN 0-943299-16-0

Manufactured in the United States of America
Printed on recycled paper with soy base ink

Dedication

To my father with loving memories. His artistic talents, creative genius and strength of character have been my greatest inheritance.

ABOUT THE AUTHOR

MARYANNE E. HOFFMAN

Maryanne E. Hoffman is also the author and illustrator of **Personal Dream Diary, The Goddess Guide, Astro-Guide** and the **Star Guide** column for *Body Mind Spirit* magazine. Maryanne appears as a talk show guest on T.V. and radio stations across the country.

Her achievements include Master's studies in Art and Art Education from Ohio University and a Bachelor of Fine Arts degree from Ohio State University, where she pioneered the field of Art Therapy. Ms. Hoffman began her undergraduate studies in medical technology at Youngstown State University.

Maryanne has recently established **RAINBOW RISING**, a private educational institute that offers several in-house and correspondence courses and certification for Color Therapy and Color Specialties. She instructs Color Therapy, Aroma Therapy and Color Specialties at Lakeland Community College in Mentor, Ohio.

Currently, Maryanne conducts workshops and classes on her books and does astro-counseling. As a world traveler, she shares her colorful insights and knowledge with people all over the world. She encourages you to follow the rainbow in your heart and make your dreams a reality.

CONTENTS

FORWARD

In this book about color you will find many new ways of utilizing a rainbow of colors in your life. Although the beneficial healing quality of color is an ancient concept, its use for self-understanding, personal development, and greater awareness of the whole self is innovative and becoming more popular.

The development of Art Therapy, Color Psychology, Color Therapy, and various color tests, have all brought the significance of color to our attention. Ms. Hoffman, in this practical survey of the color spectrum, shares with us her thoughts, ideas, and suggestions for making color a significant part of our everyday world.

Her personal style and sensitivity to color consciousness comes through clearly. As you read this book you will note the author as person and as artist behind the color being explored from section to section.

The mandalas preceding each section highlight the material Ms. Hoffman has presented. She keenly uses these original circle drawings/paintings to facilitate personal centering and overall mental calmness. She also uses this unique art to help bring us into clearer focus and better balance in body, mind, and spirit through basic color imaging and color meditation.

Ms. Hoffman makes colorfully clear her emphasis on the utilization of color as a reflection of the self. She gives her general viewpoints about color significance in dreams, thus expanding upon the material in the preceding sections. She looks at some of the basic types of color dreams and offers a beginning way to record the important remembered content of the dream.

This second edition includes more information about color by presenting the reader with a basic introduction to the changing colors of the human aura and their possible meaning. Another exciting addition is the inclusion of colors beyond the rainbow - neons, pastels, metallics, and iridescents!

Finally, interspersed throughout this newly revised work is the power of color combining and the specific signals one emanates to others when these combinations are worn.

At the very least, the reader who journeys through this book will come away with a keener awareness and appreciation of the many influences color has both consciously and unconsciously throughout your daily life.

Richard C. Rule-Hoffman, MA, ATR, LPC Adjunct Professor of Art Therapy

INTRODUCTION TO THE SECOND EDITION

Color is the essence of the life force. It is a scientific phenomenon that we receive all visual knowledge through electromagnetic radiation. Light, visible and invisible, is a narrow band of an electric field. This field is comprised of long and short waves, which are indicated by their specific colors. The gradation of color creates the spectrum known as the rainbow.

Color doesn't exist in reality. It is actually a sensation in your consciousness. You are able to perceive color through the retina of your eyes as light passes through them. When you are looking at an object, the sky, or a person, you absorb a series of multi-wavelengths of light that travel at the same rate of speed and are reflected from that object. Objects, nature, and people are colorless. In truth, they absorb certain wave lengths and reflect others. You perceive color by the cerebral cortex which is at the back of your head.

There are seven major colors of the rainbow, seven major notes of a scale of music and there are also seven major energy fields in the human body. Our body functions like a computerized storage battery. There are points of energy where vibrations are absorbed into the system, stored, saved, and released. Their degree of functioning is greatly determined by the way we live our lives and how we express ourselves. Our body and soul radiates its' own energy field known as the aura. Your physical, mental, emotional and spiritual condition can be monitored according to the different colors of your aura. Inability to cope with certain aspects of life will usually manifest as physical symptoms in a specific area of the body. However, you can tune your energy fields into greater balance through the positive and correct use of color.

Is reality what you visually see? Is what you perceive in your imagination real? What you see and also, what you imagine in your mind's eye has a direct and powerful effect on your entire self. What you think, you become through your senses. You are what you *think* you are. Therefore, it is important to think upon positive and creative thoughts to create a beautiful you.

You can use color to help stimulate your thoughts and to direct its beneficial energy to different areas of your body for a more healthful you. Knowing the proper use of colors will help provide understanding, personal development and greater awareness of your whole self.

Maryanne Hoffman

PREFACE TO THE SECOND EDITION

The creative motivation that sparked my need to compose *The Rainbow In Your Life* second edition developed through requests from readers, my students, clients and T.V.- radio audiences who found the information and color exercises in the first edition helpful in their lives.

Through the desire to give more detailed information on colors the second edition was created. The new chapter entitled *Your Power Colors* provides you with the different color types, such as the popular neon colors and their specific impact. Throughout each color spectrum chapter you will find the important meaning and influence colors have, when combined with a specific color. The blending of colors can be very self-empowering. I have received numerous requests for what colors you should wear for a specific occasion or just to improve your lifestyle. Since the results were so successful, I decided to include this information in this edition. You will find the user friendly pages quite easy to look up a specific color and have its powerful color combinations right at your finger tips.

You may find the chapter entitled *Your Aura* quite interesting. The information is designed for you to explore the possibility of being able to see and understand your's and other's auras. There has been much scientific data to substantiate the evidence of the aura and extensive research on the meaning of their colors. Enjoy exploring this incredibly real phenomenon!

Through my visionary eyes of the artist within, this book was created. The information contained within these pages is the direct result of a continuing discovery of color through my years of teaching art and color therapy, and extensive research and lecturing on color to a varied population of individuals in different settings.

This book represents my rainbow palette of color expressions that have been successful for myself and many others. I'd like to share with you these colorful experiences and invite you to explore *the rainbow in your life*!

Maryanne Hoffman, 1993

EXPLORING YOUR RAINBOW: A PERSONAL JOURNEY

Let's begin a simple and fun journey into your world of color. The ways you color your life reveal much about where you are in your life experience and how you use your personal powers.

Before and after you absorb the entire book, complete the following exercises on color awareness in your daily life. Get to know yourself better through coloring your personal world. Most of your color choices reflect the light that you project outwardly; that is, within your very being.

This is not a psychological test - it is a self-discovery journey, designed to create awareness of your unique individuality as a person and to bring you in touch with where you are in your life space.

You are invited to journey into *the rainbow in your life* and discover who you truly are!

YOUR RAINBOW JOURNEY

1. Colors reflect the soul, mind, body and spirit of the total you. Think of the following colors in their purest form: red, orange, yellow, green, blue, indigo, violet, black, white, gray, and brown. Now list from 1-10 your most favorite of these colors to the least favorite (do not relate them to objects). If you choose to let the artist in you out, paint or color a rainbow of ten layers. The top arch is #1, your favorite color: #2 arch, your next favorite, and so on. The last arches should be your least favorite or most disliked colors. This is your personal color rainbow at the present time.

2. Review your wardrobe and list the three most dominant colors.

3. List three colors you've been wearing more frequently.

4. List three colors you are especially attracted to.

5. List the three dominant colors in the favorite foods you eat.

6. What three colors dominate the liquids you drink?

7. What three colors dominate in your home interior decor?

8. What are the three colors of your car (interior and exterior)?

9

9. Which do you enjoy the best: sunrise, high noon, sunset?

10. What is your favorite season: winter, spring, summer, fall?

11. Which color do you like best: red, blue, yellow?

12. Which color do you like best: orange, purple, green?

13. Which color do you like best: black, gray, white?

14. What two combined colors do you like best?

15. Which shape is most appealing to you?

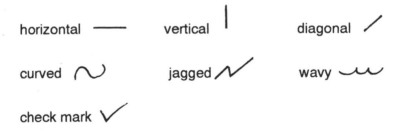

16. Which line is most appealing to you?

COLORING YOUR SENSES

The rainbow in your surroundings is absorbed and felt by all your senses: sight, touch, hearing, taste, and smell. Now discover an unusual way of experiencing your senses, through describing them in *color*. Do your best and use your imagination.

For example, when trying to think of a color that represents the sound of an alarm ringing loudly, relate it to how it feels to you. It may sound like the color **red** for its loud, urgent, shrieking tone. Now, describe in color the following sensation experiences from awakening this morning.

What colors would relate to:

1. On opening your eyes, what colors did you focus on?

2. List the color that describes what you first felt.

3. List the color that describes what you first tasted.

4. List the color that describes what you first heard.

5. List the color that describes what you first smelled.

6. List the color or colors that stand out in your dream.

COLORING YOUR PRIVATE SURROUNDINGS

Colors in your intimate surroundings have an immense effect upon you, whether or not they are of your choosing. Select three of the dominant colors for each private sector of your living and working environments. If only one color is prominent, list three times. If only two colors apply, list twice the dominating one.

Example: If your living room is a variation of blues with a dash of mauve, list blue twice and mauve once; dark royal blue, powder blue, mauve.

Kitchen	Laundry Room	Children's Room
Playroom	Study/Den	Other Rooms
Work Area	Exercise Area	Optional Space
Bedroom	Bathroom	Dining Room
Living Room	Family Room	Basement

CONCLUDING THE FIRST PHASE OF YOUR RAINBOW JOURNEY

Congratulations! You have just completed the beginning phase of your rainbow journey. Now you are ready for greater understanding of yourself. List each color you selected from every group. Give one point for each time a color is listed in the exercise. Count how many times you used that color and mark it down. Even if you used various shades or pastels of the same color, give it a point.

Example: If you listed dark green, bright green, and sea green, all three fall under the category of green. Also, list the color that is closest to the pure color. Example: mauve is placed under violet; maroon under red; and chartreuse under green. See the color key in the *appendix* for the color interpretation of question numbers 9, 10, 15, and 16.

COLOR CATEGORIES

Red, Orange, Yellow, Green, Blue, Indigo, Violet, White, Gray, Black, and Brown.

List the three colors that receive the most points.
Do the three prominent colors agree with your personality?
Are they your favorite colors?
Do you also wear these colors frequently?
Do you like these colors?

If your answers are a YES, then you are living in an environment that is harmonious to your well-being. If your answers are a striking NO, then your surroundings are not harmonious with your total self.

Ideally, your environmental and personal color expressions should reflect your inner being and personality. In a family setting, each individual needs to have a choice of color schemes, at least in his/her bedroom or a particular room designated to that person. It is vital to the balanced development of the entire person. Therefore, it is important that you wear or surround yourself with colors that enhance your personality and make you feel comfortable. What color is good for one person is not necessarily good for another.

Nature is consistent in her color changes, which provide you with a stable existence on earth. These pervasive color effects from nature can shape your behavioral patterns and affect your mood. The various colors in your natural environment affect you subliminally (without conscious awareness). Consequently, it has been proven that people from tropical environments have different temperaments than people from seasonally changed environments.

How often do you find yourself changing the color schemes of your home, work space, and wardrobe? As an individual you are constantly growing and changing with your life situation. However, *colors* never change. You change your color choices. Wouldn't it be spectacular to be able to change the colors of anything at your command? It can become quite an expense to redecorate your surroundings and constantly change your wardrobe to reflect your current awareness of life and to express how you feel, both psychologically and physiologically.

But of course, you need changes to grow and become yourself in the here and now.

There are several simpler ways to incorporate colors that reflect the new you and your daily moods. One is to add clothing accessories of these needed colors to your wardrobe and another is to add flowers of these particular colors to your environment.

It is unnecessary to make complete color changes to everything. As long as the colors are somehow integrated into your life space you will feel more comfortable and be able to express the new you.

REFLECTIONS OF YOUR RAINBOW JOURNEY

From the completion of your first exploration, let's examine your three dominant color choices. If your three colors fall into two or three variations of the following colors: red, coral, orange, peach, yellow, yellow-orange, maroon, warm brown (orangish), pink, and magenta, you are an extroverted person, actively seeking change and leadership positions. You are admired and looked up to for your strong convictions and ambitious nature.

If you chose two or more of the following variations: blue, blue-green, turquoise, aqua, green, olive, purple, indigo, and navy, these are the cool colors, more passive in nature and other-oriented. You like to consider other's opinions and are willing to compromise. You like peace and quiet, and often need to retreat from the outside world. Others may see you as a good follower or quiet leader.

If the neutrals, white, gray, brown, and black dominate in two or three selections, you are in an interim phase in your life situation. You may be on the periphery of great change.

In summary, if you are in the warm category, you are an outward person needing an environment that will adapt to all your activities. Falling in the cool category, you are an inward person who needs an environment not so stimulating but more soothing and peaceful where you can feel secure and nurtured. Finally, if you are in the neutral category, you desire an environment filled with many activities and choices in order not to be bored. You are open to numerous changes in activities as well as moods.

This is a simple assessment of your color scheme as it applies to your life spaces. In further chapters you will explore each color more specifically. *You have just colored the surface!*

YOUR POWER COLORS

The most effective colors to enhance your desires and to promote your personal power are the seven colors of the rainbow. Wearing these colors in any color type combined with one another and/or the neutrals brown, gray, black and white convey unconscious messages to others around you.

You can use color to your advantage in any personal, business, social, or formal situation. Color is the power of the unspoken word and sends out signals loud and clear. When considering the color combinations in each chapter under the section **Power Color Combinations** think of the major color as a man's suit or a woman's outfit and the accent color as a man's tie or a woman's accessories. Example: gray with yellow. Gray is the major color and yellow is the accent color. A gray suit with a yellow tie may be informing others that you are amicable in spite of intellectual differences. You may hold your own ground on a particular issue and disagree with a positive self-assurance, dispelling arguments from others. The yellow tie in business has been considered the power color tie. The gray suit is the perfect business person's color.

The colors you wear project a particular image to others. They can enhance your personality and affect how you relate to others and how others respond to you. A color in its purest hue has a stronger impact. Pastels and tints soften the effects of the main color, while shades and tones subdue or lessen the effects of the main hue. Put yourself in the power seat and use color combining for your benefit and for your own self-empowerment. Have fun exploring and experimenting with color combinations!

COLOR TYPES

NEON

Neon or day glow colors reflect the brightest rays of the sun and have the most exciting effect of all color types. The brilliance and *sunsation* of these vividly blinding colors is ultra stimulating to the senses. The fluorescent colors are visually captivating and are distinguishable at a greater distance than any other color types. These are the action-packed colors that evoke a sense of fun, adventure, excitement and spontaneity. Combined with highly contrasting black their effect is immensely intensified and more striking. Next to white, their glowing radiance is greatly increased. Wear neon colors to bring out the child within you. Neon colors are playful, festive and highly visible. To be noticed, even in a large crowd, wear neon colors.

BRIGHT-VIBRANT COLOR

These are the true colors of the rainbow as seen in nature. Colors that are purely saturated without a tint of white or a shade of black help evoke a positive disposition and increase self-esteem. Wearing vivid hues lifts the spirits and evokes a stronger effect more than any other color types. Others will take notice of you and pay attention to what you have to say, when wearing these light-hearted colors.

PASTELS AND TINTS

Pastels are colors that contain a large amount of white and are the lightest form of a color. Tints are colors that contain white and are more saturated in hue than pastels. The gentle quality of pastels and tints soften the effects of the main color. Pastels are considered spiritual colors that evoke a sense of weightlessness, buoyancy and lightness. There is more light reflected from pastels. The vibrations are subtle and celestial. Wear pastels to mellow out, to exude your beauty and personal charm and to elicit kindness and gentleness from others.

TONES AND SHADES

Colors that are mixed with gray are tones. Colors that contain black are shades. Tones have a dulling effect and diminish or subdue the affects of the particular hue. Shades appear heavy and evoke sophistication, conservatism and a serious approach to situations. Wear muted shades when you mean serious business, and tones when you want to appear a bit conventional.

MONOCHROMATIC

Monochromatic is the combination of one or more pastels, tints, shades, or tones of the same color. This is one of the most pleasing and balanced color combinations. Wearing the same color with a variation of tints or shades etc. always has a harmonious and captivating appearance. Take green for an example. You may have a need to project a prosperous and stable family image. Wearing a dark green with mint, or emerald green with sea green conveys your message even stronger and clearer than if you were to wear green with a neutral or another color. If you have difficulty color matching or color combining, choose a monochromatic color scheme. Monochromatic colors are tasteful and have a greater impact and power conveying a specific message.

SPECTRUM IN RED

Red is the color of pure energy, the flame of love, passion, and courage. It is the vibrant force of life itself! Its dynamic effect brings you intense experiences and fullness of daily living.

Red is the first primary color of the spectrum. Packed with power, it is invigorating and forceful in nature. Red is impulsive and quick in response. Its sensual vibration sparks your creative urges and physical appetite. The attributes of red are freedom, leadership, will-power and action. The opposite effects are force, anger, impatience, violence, and revenge.

ENVIRONMENTAL EFFECTS

SURROUNDINGS

Add a dash of red to your surroundings to stimulate creative activities and to revitalize the physical body. Red adds life to a room.

Family - Red is great to bring attention to yourself. Red can invigorate and motivate a group to perform chores or participate in sports together in an energetic way. It brings liveliness to the family and in appearance creates the feeling of creative competition. The more mature members of the family seem physically equal to the younger members.

Children - Red will help motivate a physically lazy child to perform chores and to partake in family sports and fun activities. Rose red enhances creativity and productive, enjoyable activities.Pink is the color of daydreaming and fantasizing.Its soft sensation is great for creative play for a child's playroom. Children do not feel as confined or limited in a pink environment.

Pets - Even though most animals do not perceive color, they can and do feel the vibrations of color. Red stimulates activity for an older animal. It creates over-activity for young or healthy pets. Rose is preferred to adorn your pet with affection. Pink is great for loving interaction among children and pets. It seems to tone down the animalistic nature and appeal to the animal's gentle nature.

LIGHTING

The warm quality of reddish lights creates a stimulating atmosphere for dining. Its desirable nature helps you enjoy eating; the sense of taste is livelier. Red also seems to affect the sex drive and stimulates creative activity. Plants grow at a quicker rate and are energized by red light.

PHYSICAL EFFECTS

HEALTH

Red stimulates the body in a constructive manner. It is used for stopping hemorrhages and the production of red blood cells. It is a vital vibration for increasing physical strength to the entire body; it empowers you with the will-power to live!

Scarlet is a brain and arterial stimulant and reduces inflammation. It is a kidney energizer and boosts the morale. It increases your vitality and courage. It is a general healer throughout the body.

Pink affects the mind more than the body. As a universal healer, it raises the vibrations of the body, and is used for rejuvenation.

FOOD AND NUTRITION

Eat red fruits and vegetables for iron, copper, and B vitamins to increase your vitality. Most red foods are delectable, appealing, and tantalize your taste buds as well as excite your appetite.

PHYSICAL EXERCISE

The competitive nature of red enables you to react quickly in an unanticipated situation. It alerts the body to rapid action. It is the best color to use for competition and to instill the will to win in an individual or a group. It is excellent for all sports and activities where speed, endurance and physical strength are essential for optimum results. Red is great to help you shed those unwanted pounds and give you the energy to engage in aggressive exercising and daring sports. It helps in all competitive sports and situations where winning is important. Wet your physical appetite and use red!

PERSONAL EFFECTS

If you favor red, you may demonstrate an aggressive manner, assertive attitude, and an out-going personality. Personal survival and pleasurable satisfaction are paramount in your daily routine. Red is popular with the extrovert, and the dynamically energized per-sonality. It's important for you to lead a physically active and adventurous lifestyle. Impulsively traveling on the spur of the moment, excitement is your motto. You are charged with great endurance and are highly spirited in all your projects and activities.

FASHION

Wear **red** to invigorate you, to become self-confident and to attract attention. Red stimulates physical activity and helps you lose weight. Wear red to feel young!

BEAUTY-PALETTE - Colors enhance your total appearance, especially when they are harmonious with the shade of your hair.

Pale Blonde: Soft coral and bright red
Dark Blonde: Pastel pink and medium red
Red and Auburn: Bright and neon pink
Light Brunette: Red, dusty rose, crimson, and burgundy
Dark Brunette and Black: Red, maroon, rose pink, and scarlet
Gray and White: Bright red and all hot shades of pink

JEWELRY - Wear a red gem to promote a long, healthy life. Place a pink gem under your pillow for peaceful dreams. The rose tones create this effect best. Rejuvenate yourself and wear a red gem! Examples: ruby, garnet, and rose quartz.

CAREER - FASHION

Red is great for occupations where physical strength or a lot of activity is required. Do not wear this color on an interview; it is very intimidating, especially with white. It's an excellent color for working with children and the physically challenged. Rose is charming and delicate in nature, enhancing a career with its beauty. Dance, cosmetology, the arts and all creative fields reflect this vibrant color. Pink is best avoided, with the exception of people in powerful or intimidating positions. It will soften your character and present an image of youthfulness and an open mind. It is not threatening to others. It is most helpful for women executives and clerks to give a flattering appearance.

THE POWER OF RED

Red is the ultimate color for physical action, conquest and vitality. Your personality is fully animated when you wear red. You appear ardent and motivated toward success with a zest for life. The lively intensity of red helps you dominate situations and people.

Pink is a pastel of red and **rose** is a tint of red. Rosy pink is rejuvenating. You want to be treated with kindness and affection. Pink exudes physical gentleness, tender love, youthfulness and softness. You desire to be cuddled and pampered like a baby. Pink weakens an aggressive nature.

19

Burgundy is a tone and **crimson** is a shade of **red**. Both are re-energizing. The darker the shade the more subdued the desire for control and aggression. You handle your passionate nature and ardent desires maturely. You evoke an adventurous spirit with reason and practicality.

POWER COLOR COMBINATIONS

Red with Orange - You project an overly expressive and reactive nature. You desire to concentrate your intense energy on one particular experience with the ability to change your focus at a sudden notice. You express hyperactivity and spontaneity. A great combination for sport teams and energetic activities.

Red with Yellow - You desire to experience life to the fullest. You express enthusiasm and receptivity to new experiences. Your self-confidence and optimistic nature makes you a winner. You intensely strive to achieve your goals. A great combination for individual competitive sports.

Red with Green - You have a need to be assertive and exercise great will-power toward pursuing your goals. You project a domineering and self-assured personality. Wear this combination, especially rose pink with mint or emerald green to express a strong will and a lovable disposition.

Red with Blue - You project a desire for a life of rich experiences and intense involvement. You desire an intimate relationship with emotional and sexual bonding. Wear rosy red with deep blue in situations that require benevolence and acceptance from others. Wear burgundy with navy blue for sophistication and to evoke maturity and a serious compromising nature.

Red with Indigo - You need to become more assertive in seeking an intimate relationship that is trusting and loyal. You are a dynamic and courageous leader in groups that fight for a cause. You express your individuality in groups and strive for unity among diversity. Wear red with navy or royal blue in a leadership role that impels others to action. Wear pink with light indigo for gentle persuasion among family or group members.

Red with Violet - You project a magical personality with romantic charm and sensual effervescence. Very seductive in nature, you can have a magnetic hold with considerable influence on others. Wear these colors to bring excitement back into a stale relationship.

Red with Brown - You renounce personal ambitions for prestige and success in order to have security, a measure of stability and domestic comforts. You express enthusiasm and contentment as a household member. Wear red or rosy pink with tan or beige to put ambitions aside and allow yourself to indulge in pleasures.

Red with Black - You desire complete intensity in all your involvements in order to make-up for what you feel you have missed in the past. You want to break free from people and situations that hold you back. You project a "do or die" mentality. A great combination for an evening of pleasure and excitement.

Red with Gray - A risk taker, you may act impulsively, in order to avoid others that prevent you from experiencing exciting and special opportunities. You appear outwardly secure but are inwardly noncommittal and/or undecided. Excellent colors to wear in situations that require acts of courage or an emergency.

Red with White - You have an intense desire to be audacious and in total control of expressing your passions and ambitions. You project an aggressive and intimidating personality. Wear this combination to demand attention and to be the boss or leader.

ZODIAC SPECTRUM

The day and month you were born determines your zodiac sign. Your unique planetary portrait reflects the rainbow in specific nuances of each hue.

Aries: red and bright, rich pinks
Taurus: pastel pinks, rose
Gemini: brilliant red
Cancer: dusty rose
Leo: scarlet
Virgo: maroon

Libra: hot shades of pink
Scorpio: deep red, crimson
Sagittarius: deep rose
Capricorn: burgundy
Aquarius: tropical pink
Pisces: pearl pink

RELATIONSHIPS

LOVE AND ROMANCE

The colors you favor and wear project a particular image to others. They can enhance your personality and affect how you relate to others, especially in your personal relationships.

As a **red** lover you have a real lust for life. You are optimistic, enthusiastic and high spirited about your relationships. Being intensely involved on a sexual level, you are extremely passionate. The brighter the red, the more virile you are. You enjoy a challenging relationship and may even thrive on the challenge. You like various activities and are self-determined, leading the relationship by your out-going nature. Your partner may make suggestions, but never is he/she to tell you when and what to do. You need occasional time and space away from the relationship in order to involve yourself in all your individual enterprises.

Pink and Delicate Rose - You exhibit child-like or youthful behavior and want to be pampered and treated delicately. You expect the relationship to express a special puppy love quality. You enjoy giving and receiving little, thoughtful, cutesy gifts and notes, but sometimes you can be a bit mushy.

Light Red - You tend to be a little ego-centered, demanding to control the direction in the relationship. Be more giving.

Dark Red - You tend to be domineering and stubborn toward a partner. Try to control your hot temper and learn to take a couple of deep breaths before releasing your anger or impatience. Cultivate deeper feelings and respect for yourself and the relationship.

Scarlet (Red-Orange) - You express your ego desires through your partner's outstanding traits. Your partner must have an attractive appearance, be physically fit, and enjoy a lot of activities.

Red stimulates the desire for sexual expression and physical delights. Rose and bright pinks create a fun-loving time together. Their rejuvenating qualities enhance a party and stimulate the playful child in you. The deeper reds are not as stimulating, but are effective in releasing intense emotions. Bright red can rekindle an old or dying relationship. Red can add a spark of life and pleasure to your relationship.

FRIENDSHIP

Red stimulates the spirit of activity in physical sports. It can challenge a friendship through competitive games and fun activities. Red can be both intimidating and invigorating. Rose is an affectionate color, bringing love into the relationship. Pink instigates the need to be childlike or playful in your interaction with others.

COLOR HARMONY

Red and Orange - Both are warm and analogous to one another. They are very stimulating to the appetite, the muscular system and the nervous system. Both are harmonious in light or dark tones of the same consistency. They are not as appealing if one is dark and the other light.

Red and Yellow - Both are primary hot colors. They are over stimulating and fight each other for attention. Together their intensity grabs your attention.

Red and Green - They are complementary to one another and opposite on the color wheel. They express the interplay of hot and cold. Pink or a light tint of rose with bright green is most pleasing.

Red and Blue - Red and blue are both primary colors and are the strongest combination of hot and cold. Visually they appear to be moving in an "in and out" pattern when placed next to each other. Red advances forward and blue recedes backward. This subtle movement attracts attention. Consequently, red and blue are the most favored pair of colors by most adults. This combination is very effective in advertising because of its mass appeal.

Red and Indigo - These colors are a harmonious match, especially since indigo contains a small amount of red. The fire quality of red and the cold receptive nature of indigo balance each other. Rose pinks are very appealing with indigo, however light indigo and bright red are not too appealing. Red appears stronger and is noticed first. Indigo quietly appears passive. Perceptually you might think that indigo has more depth and red more appeal.

Red and Violet - Both are analogous. They are the sensation of hot and lukewarm. Rose and lighter red with violet creates a charming appearance. Red with lavender or a light shade of violet are not as appealing to the senses.

VEHICLE

The color you choose for a car, boat, bicycle, etc., outwardly reflects your inner needs and personality. Only the color you prefer for a vehicle applies to the information below.

Red - If you prefer a red car or any motor vehicle, you are probably looking for adventure, excitement and fun with it. Red is the color of energy and speed. It is the quickest moving vibration of all the colors. A bright red car, boat, or train, even when standing still, appears to be moving. The brighter the red you choose, the more dynamic and daring is your approach behind the wheel. Favoring maroon, burgundy, or more deep and dark subdued tones of red, the more self-controlled is your need for aggressive expression. However, choosing pink or shades of rose for a vehicle marks you as a person who wants to be pampered and stand out as an individual with unique taste.

SENSES

Sound - Red is the musical note of C. High pitched sounds and lively dynamic music vibrate the color red.It stimulates the nervous system and the muscular system.The sound is so powerful that you are urged to dance or to engage in vigorous activity. Red promotes the release of energy to combat stress.

Touch - Red is the sensation of heat. It is hot as a flaming fire or dry as the hot desert sand. Intense red is like a melting metal rod of extreme heat.

Taste - Red is pungent and found in stimulating spices, especially hot ones such as cayenne pepper and cinnamon. It stimulates circulation, digestion, and mental alertness. In excess it can cause irritability, over eating and dehydration.

Visual -Tantalizing and sensuous, red flirts with the eyes. Alarming and alerting in its impact, it impels you to look at it and take particular notice. Pinks and rose shades beckon you to enjoyment and romance. The lighter shades are suggestive of youthfulness and babyhood. The deep tones of red are reminiscent of blood and subdues vitality. Red puts your entire system on alert.

Scent - The fragrances of red are patchouli (rose pink), sandalwood (deep red), geranium (bright red), rose and jasmine.

Form - Shape: the square relates to red.
Line: the vertical line expresses the feeling nature of red.

DRAWING EXERCISES

Since ancient civilization through modern times, humankind has utilized symbols to express itself. Symbols are a universal language which conveys specific meanings. One shape can evoke a deep response and express many words.

You have been made aware of how colors relate to shapes. Through the process of creating a square, which expresses the specific color **red**, you can experience the feeling and energy of that color. You can draw or doodle a square on paper, inscribe it in the sand, or in mid-air. Making a square will help empower you to achieve the following:

1. to become courageous and to overcome fears;
2. to become motivated;
3. to become grounded and feel secure in a job, relationship, or life situation;
4. to begin a physical task;
5. to empower yourself with energy and vigor before exercising.

MENTAL EXERCISES

IMAGERY

Think **red** to have courage and motivation, especially to start or complete a task at hand. Think rosy pink to rejuvenate your body and mind.

MEDITATION

Close your eyes and visualize the color **red** as you breathe it into your body through your feet and up through your head. Sit or lie down with your spine straight and imagine the color red in its purest form, as a brilliant red beam. In your mind's eye, see the room filled with red and breathe red. Allow the color red to fill your entire body and feel its dynamic energy penetrate every cell. Feel red flowing through your blood stream, filling your entire body from head to toe with pure energy. Now feel the invigorating force of its vibration and become one with this powerful force. Become thoroughly energized!

SPECTRUM IN ORANGE

Orange is the color of the luminous setting sun. It is life's creative force- the pulse of nature vibrating through the earth. It symbolizes the harvest- the abundant fruits of the earth. The mystery of time is its essence. Use orange in your daily life for positive social inter- action.

Orange is a secondary color comprised of the primary colors yellow and red. It contains both qualities of these colors. Its attributes are stead-fastness, courage, striving, confidence and change. Its opposite effects are ignorance, inferiority, cruelty, sluggishness, pompousness and superiority. Exuberant in vibration, it is the spark of genius in creative form.

ENVIRONMENTAL EFFECTS

SURROUNDINGS

Orange surroundings have a high appetite appeal and create a friendly atmosphere. Peach is the most livable and charming color for the home or office. It promotes thoughtfulness and consideration toward others and increases your social interactions.

Family - Orange stimulates fun and excitement in the family setting. It is the color of the laughing clown and the effervescent mother. It creates a friendly atmosphere for lively family discussions and brings members together especially at meal time. Warm peach is wonderful for gentle and soft interplay with family person-alities. It adds a warm, tender feeling to the home atmosphere.

Children - Orange is an ideal color to bring a quiet, shy child out of his/her shell. Its friendly nature stimulates interaction among playmates and helps an inactive child become more involved. Orange also helps to promote sharing and polite social interaction among introverted children. Peach tones influence the qualities of graciousness and consideration toward others.

Pets - Pets will eat more and quicker in a bright orange space. Peach tones are more enhancing and warming to the personality of your animal. It will help make a shy pet more friendly and stimulate interaction among animals.

LIGHTING

Orange is very stimulating to the palate and is excellent for social dining. Plants tend to grow taller, yet thinner under orange lights.

PHYSICAL EFFECTS

HEALTH

Orange is a body normalizer and helps relieve asthma, respiratory disorders, cramps, and spasms. It helps indigestion, provides relief for ulcers, and improves the thyroid. It replenishes depleted enthusiasm and vitality.

FOOD AND NUTRITION

Orange fruits and vegetables are rich in vitamin B. Orange table linen and tableware, as well as surroundings, increase your appetite and stimulate excessive eating.

PHYSICAL EXERCISE

Orange will give you the confidence to do difficult or silly routines in a group. It will provide you with a happy disposition toward your exercise program. Orange is great for group activities where everyone must participate equally. It enhances teamwork and camaraderie. Orange signifies glory and promotes the positive attitude to be victorious in competitive sports. Use orange and "go for it!"

PERSONAL EFFECTS

Selecting orange as your favorite color shows that you have high aspirations. Although considerate and cheerful toward others, you will take full advantage of a social situation to achieve your ambitions. You desire success and most likely will achieve it through popularity. Your inventive ability and self assurance marks you as a creative leader. Proud and self sufficient, you are admired by many for these qualities. You often operate through logical deduction and intellectualization. Self-control is essential to your emotional well-being.

FASHION

Wear orange and its lighter tones for a cheerful glow, for self assurance, and to assert yourself. It stimulates socialization in a cheerful and amiable way. Peach enhances the expression of style and grace in appearance.

BEAUTY - PALETTE - Colors enhance your total appearance, especially when they are harmonious with the shade of your hair.

Pale Blonde: Golden orange, soft coral and peach
Dark Blonde: Deep orange and apricot
Red and Auburn: Bright yellow orange, neon orange
Light Brunette: Rust orange, orange
Dark Brunette and Black: Peach, apricot, subdued orange
Gray and White: Peach, salmon

JEWELRY - Orange and coral gems promote self-control and congeniality and indicate a strong and endearing friendship. Express your generosity or seal a relationship by giving one to a friend. Example: coral stone.

CAREER- FASHION

Since **orange** is one of the bright, outgoing colors of the spectrum, it is best suited for a position where you are working with children. It projects a friendly and thoughtful disposition and a playful personality. Fast food restaurant clerks and attendants are cheerfully presented in this hue. A splash of orange with gray or light, warm brown is gregarious and attention getting in most professional situations. It will stimulate group involvement. The lighter or pastel orange and peach are a great soft accent for greens, browns, tan, white and even blue violet. These warm combinations will enhance your ability to be diplomatic and genuinely warm in a job that requires social interaction with others.

Orange is best for any occupation dealing with groups of people, especially for the teacher, salesperson, waiter, and hostess of a party.

THE POWER OF ORANGE

Orange is the color of sociability and projects a fun and gregarious nature. It stimulates a sense of humor and lively conversation and helps you look at the bright side of a situation and relationship. Orange is stimulating both to the mind, capturing spiritual and intellectual wisdom and to the body through increasing your appetite. The lighter tones of peach, salmon, coral and apricot adds an attractive glow to all skin tones and projects comfort and warmth in social settings. The darker shades like rust, or tones like brownish hues, evoke a sense of social stability and a friendly stable personality and lifestyle.

Peach and **Apricot** are pastels of Orange. **Coral** and **Salmon** are tints of Orange. Especially peach and salmon project social grace, charm, diplomacy and a warm personality. They are gently persuasive and spiritually wise. You evoke self-control in situations with fair play toward others. All of these are the best colors for friendly social gatherings and in making a positive, memorable impression.

Burnt Orange is a shade of orange and **Rust** is a tone of Orange. You have a deep yearning to experience life sensuously and with all its earthly comforts. Orange shades and tones project an earthy lust for life and a controlled sense of fun.

POWER COLOR COMBINATIONS

Orange with Red - You are demanding and desire to be the center of attention. You expect to achieve through others' help and assistance. You project an air of importance. This is a great color combination for a backward or shy person, especially a child, to help develop social skills and to overcome timidity.

Orange with Yellow - You have a strong desire for positive acceptance. You elicit attention and expect friendly interaction with others. You are hopeful that others will like you and your ideas. Wear this combination when you want to meet new friends.

Orange with Green - You project a warm, yet controlled personality. You have a desire to be friends with everyone. Wear light orange, or peach, salmon, and apricot with a darker or deeper green to express social grace and congeniality. Wear peach or any pastels and tints of orange with emerald or deep green as a dinner or social host/hostess.

Orange with Blue - You project a wild and gregarious personality with a sense of humor. You have a desire to be popular. Wear the deeper subdued shades of rust with navy blue in formal situations that require a friendly and responsible disposition. Wear peach with deep blue for congenial social affairs or open family discussions.

Orange with Indigo - You have a need for support and emotional bonding with your family. You project an amicable image and loyalty toward a cause or a spiritual group. Wear peach with periwinkle or light indigo to express a congenial and trustworthy disposition. Wear rust or deep orange with royal blue or vivid indigo to network for the benefit of others and to help bridge the gap be-

tween co-workers in professional situations.

Orange with Violet - You have a need for social acceptance and to live your ideals. You express your originality in unique ways or project the image of a harmless rebel. Wear coral with purple or deep violet to help stimulate the imagination of others in a group setting.

Orange with Brown - You project a warm personality with a down to earth attitude. You have a need to enjoy all that nature has to offer. Wear peach, coral or salmon with tan or beige for congenial interaction in social gatherings with children or groups.

Orange with Gray - You have a need to control your outgoing or flamboyant personality with a warm and serious demeanor. You project a fun-loving, delightful personality, while being discriminating toward others. Wear orange with charcoal gray to help tone down a boisterous or loud personality. Wear peach, coral, and salmon with all grays in formal or business situations that require you to be selective and objective, while remaining cordial.

Orange with Black - You have a desire to make up for what you feel you missed and to break free from stifling situations. You are amicable in a negative situation. You desire social acceptance by society or your peers. Wear peach, coral and salmon with black for congeniality and to balance your power as an authority over children or as the head of a large social gathering.

Orange and White- You have a deep inner need to be emotionally open, spontaneous and adventurous. You desire a relationship that is fun, enjoyable and playful. You project a sense of adventure and safe fun. Wear bright orange for outdoor group outings and sports.

ZODIAC SPECTRUM

The day and month you were born determines your zodiac sign. Your unique planetary portrait reflects the rainbow in specific nuances of each hue.

Aries: golden orange
Taurus: peach
Gemini: bright salmon
Cancer: apricot
Leo: bright orange and tangerine
Virgo: pumpkin

Libra: tropical peach
Scorpio: burnt orange
Sagittarius: deep orange
Capricorn: orange
Aquarius: coral
Pisces: iridescent peach

RELATIONSHIPS

LOVE AND ROMANCE

The colors you favor and wear project a particular image to others. They can enhance your personality and affect how you relate to others, especially in your personal relationships.

If you favor **orange**, you are an exuberant lover! You generally get what you go after. Having a good sense of humor and basically good natured, you seek a social butterfly as a partner. Since most of your life history is written with chapters of social contacts and knowing the right people to get ahead, you expect your mate to have climbed to the top, awaiting your arrival. Your match must be as fun-loving and spontaneous as you. Rather than passionate, you are deeply affectionate, happy-go-lucky rather than amorous. Your appetite and out-going love for a variety of people stifles your chance of marriage. However, in marriage, you are coolly affectionate and less dramatic in nature. Your sheer exuberance is best shared among many rather than through just one intimate relationship.

Generally speaking, you tend to be pretentious and less passionate than you would lead others to believe. However, you are so cheerful and gregarious that it is easy to like you, if not fall in love with you. Always ready to say a kind word or give others a compliment, you are a pleasant and popular companion.

Golden Orange - You desire a thoughtful, intelligent and considerate partner who can stimulate a good conversation. You need a socially adept, refined and playful partner.

Peach or Light Orange - Your immensely warm nature desires a diplomatic, socially graceful and romantic person. You are light-hearted and rarely hold a grudge or lose your temper in a relationship.

FRIENDSHIP

Orange is the most vibrant color for a fun and playful adventurous day. Bright orange opens up your heart and helps you to extend a warm friendly welcome to everyone. Give a peach flower to your loved one to demonstrate your deep and genuine friendship. Salmon and coral cements the love you have for a dear friend.

COLOR HARMONY

Orange and Red - are analogous and are warm and hot in sens-ation. Both will advance toward you, fighting each other to capture your attention. The overly excitable combination appears more harmonious together when both are the same tint or shade. Their expression is fast-moving.

Orange and Yellow - are analogous and are a very warm com-bination. These are the two brightest colors of the spectrum. To-gether they jump out at you and quickly get your attention, even when they are within your sight but not directly in front of you. They are harmonious in the same tone with either color dominant or if yellow is lighter or dominates the orange. Together they ex-press mental stimulation.

Orange and Green - are clashing warm and cool hues. They both contain yellow and fight for attention in the same tone. However, if green is darker and the orange is lighter they will appear more balanced. Peach, coral, and salmon (pinkish orange) are greatly enhanced with deep or bright green.

Orange and Blue - are complements on the color wheel and are completely opposite. They create a bold contrast and are pleasing as tints.

Orange and Indigo - are an unusual combination. They both con-tain red, however, red is a dominant color in orange, while it is in a lesser degree in indigo. Therefore, orange will be dominant and blue passive. Indigo in small amounts is a strong accent color to orange.

Orange and Violet - are both secondary colors. They both contain the color red. However, the other individual color comprising orange (yellow) and violet (blue) are strong colors. For this reason these two colors clash and fight each other for attention and domination. They express a wildly free nature.

VEHICLES

The color you choose for a car, boat, bicycle, etc., outwardly reflects your inner needs and personality. Only the color you prefer for a vehicle applies to the information below.

Orange - The vivid and bright appearance of orange stands out easily in most surroundings. Preferring orange marks you as an individual who likes to express a carefree and fun attitude while in the driver's seat. You literally enjoy operating the vehicle and will speed with discretion under safe circumstances. You exude a friendly disposition toward others and are considerate of their needs. You may use your vehicle to socialize and express a little flash.

SENSES

SOUND - Orange is the musical note of D. It is expressed through a heavy rhythmic beat, loud to harsh tones and lively tempo, such as rock'n roll, hard rock, and heavy metal music (stomach pump music). These vibrations affect the stomach and sex organs. It is stimulating and lively. The effect of these vibrations are great for vigorous body movements and fast dancing. Orange music is designed to move you physically.

TOUCH - Orange is warm as the rays of the sun, or hot as bursting sparks of fire.

TASTE - Orange is sour in taste, as found in oranges, yogurt, and most acidic fruits. It helps eliminate excess gas, sharpens the senses, and stimulates circulation and digestion. Orange promotes strength, vitality and firmness to the tissues of the skin. In excess, it can putrefy the blood system and cause a burning sensation and hyperacidity. The spice saffron is a bright yellow-orange in color and stimulates stomach secretions.

VISUAL - Brilliant as the sun to the eyes, orange activates the appetite and stimulates the palate. It is jovial, forceful and emanates vitalizing energy. It invokes the senses of physical pleasures and sociability. The brighter tones are somewhat harsh to the eye. The lighter tones and tints are exceptionally pleasing to the senses.

SCENT - The fragrances of orange are vanilla and almond.

FORM - Shape: the rectangle relates to orange.
 Line: the diagonal line expresses the feeling nature of orange.

DRAWING EXERCISES

Since ancient civilization through modern times, humankind has utilized symbols to express itself. Symbols are a universal language which conveys specific meanings. One shape can evoke a deep response and express many words.

You have been made aware of how colors relate to shapes. Through the process of creating a rectangle, which expresses the specific color **orange**, you can experience the feeling and energy of that color. You can draw or doodle a rectangle on paper, inscribe it in the sand, or in mid-air. Making a rectangle will help empower you to achieve the following:
1. to become more sociable;
2. to create positive changes;
3. to increase intellectual confidence;
4. to win a debate or contest.

MENTAL EXERCISES

IMAGERY

Think **orange** to manage others tactfully, to increase your appetite, and to perform emotionally determined action. It's the winner's color.

MEDITATION

Close your eyes and sit straight. Now imagine yourself in an orange room where everything surrounding you is orange. Take a deep breath of orange and let it fill you with its incandescent glow. Feel the orange atmosphere penetrate your entire being. Continue to take several deep breaths, each time taking in the breath more slowly,until your breathing is gentle and controlled. As you breathe in the orange essence, begin to feel its vital force and become completely awakened with vitality.

SPECTRUM IN YELLOW

Yellow is the color of the radiant sun - the source of life itself! Its brilliance and welcoming warmth cheers the heart, delights the mind, and enlightens the spirit. Its powerful and positive influence upon you can bring personal fulfillment in your life.

Yellow is one of the three primary colors. Visually it is the most difficult color for your eyes to focus on. It is brighter than white and stronger in its emotional impact. Its nature is cheerful warmth. It is active, self-perpetuating and out-going in response. Its attributes are joy, intelligence, organization, evaluation, and expression. Its opposites are criticism, laziness, stubbornness, cowardice and cynicism.

ENVIRONMENTAL EFFECTS

SURROUNDINGS

Add yellow to brighten your environment and to create a positive atmosphere for learning and relating to others. Even in small amounts, its glowing nature is healing to the mind as it uplifts your spirit.

Family - Yellow promotes a warm, cheerful, and friendly tone for family gatherings and for sick or recovering members.It helps stimulate a conversation in a positive direction. Interactions with family members are more joyful and positive. Yellow helps a group tackle a project with zest until its completion. It is influential in developing a brighter outlook on life.

Children - Yellow helps children develop memory retention and creates a positive attitude toward learning. The bright yellow is most enjoyed by younger children and helps them cope emotionally under negative circumstances. Yellow stimulates a conversation and brightens up their day!

Pets - Yellow is the best color to use while training a pet. It is excellent for a pet that never goes outdoors; it brings the warm, glowing, sunshine effect indoors.

LIGHTING

The warm effect of yellow creates a profound positive enhancement to a meal. Its joyful cheerfulness and mental stimulation make a meal very desirable. Amber lighting is the most popular for evening, giving off a glowing ambiance to any room. Natural yellow sunlight provides the most beneficial effects for plants and all living things.

PHYSICAL EFFECTS

HEALTH

Yellow is a great laxative. It increases the flow of bile, stomach and intestinal activity. Applied outside the body, it can reduce any type of swelling. It is a powerful stimulant to the nervous system.

Lemon relieves colds, acts as an antacid, builds the bones, prevents scurvy, and acts as a blood purifier.

FOOD AND NUTRITION

Yellow foods are highly solarized by the sunlight. Eat yellow fruits and vegetables for vitamins A and C to balance your energy. Enriched with nature's energy source, solarized foods increase mental alertness and give a radiant glow to the body.

PHYSICAL EXERCISE

Yellow is great for activities and all forms of aerobic exercise where fast movement and dance steps or memorized segments of the routine are needed. It is ideal for gymnastics, especially floor-exercise. Keep all records of physical attainments, reducing charts and weight recordings on yellow paper. Mount your ideal weight picture on a yellow background and think positive!

PERSONAL EFFECTS

If yellow is one of your favorite colors, you may find yourself involved in a variety of activities and numerous goals simultaneously. You are likened to the skillful craftsman creating form from the formless, inventing something new and progressive in your life. You have a need to modify outworn habits and stagnant circumstances in the hope of expecting greater happiness in a new situation. Your mind tends to be scientific and you enjoy intellectual pursuits. Your abundant vitality and intense commitment to your projects mark you as an unusual leader of progressive thinking, reform and creative lifestyle.

FASHION

Wear yellow to feel happy and carefree, to project warmth and cheerfulness, and fulfill your personal goals. Yellow brings attention to your unique qualities and outstanding traits. A dash of yellow creates a healthy glow.

BEAUTY - PALETTE - colors enhance your total appearance, especially when they are harmonious with the shade of your hair.

Pale Blonde: Deep golden yellow and amber
Dark Blonde: Lemon and soft yellow
Red and Auburn: All tones of yellow
Light Brunette: Mustard, ocher and all yellows
Dark Brunette and Black: Bright and vivid yellows
Gray and White: Tints of yellow and bright yellow

JEWELRY - Wear a **yellow** gem to help eliminate fear, worry and anxiety, to strengthen the mind, and to promote self-development. Examples: topaz, diamonds, and tiger's eye.

CAREER - FASHION

Splashes of **yellow** are great for most office and teaching positions. Yellow enhances a positive and intellectual image; the pale or pastel yellow is best. Bright yellow is favorable for fun jobs where you are dealing with the public or with children. It will keep your spirits up and give the appearance of knowing what you are doing. It will build your confidence to face difficult situations and people. Pale yellow with a deep or navy blue or gray is most appealing in executive positions. Avoid dark brown with yellow, it has a nauseating effect. Promote your best assets and wear splashes of yellow.

THE POWER OF YELLOW

Yellow is the color of upliftment and intellectual stimulation. Yellow projects a positive nature. You have mental determination to manifest your future desires and find solutions to current problems for new and improved possibilities. You are studious, inquisitive and adept at organizing. Yellow radiates positive regard toward the self and others. Yellow helps relationships to become stress free.

Pale yellow is a pastel of yellow. You are a visionary person with exceptional foresight into the future. You are innovative, a bit of a mystic, and hold to your own ideals in life. You are fun with a sunny disposition. You project warm understanding toward others and patience with those less intelligent then yourself.

Umber and **mustard** are tones and **ocher** is a shade of yellow. You are a serious intellectual with definite ideas about your future. You project a positive, mature and realistic personality. You have a desire to be ahead of the game and plan seriously about your future.

POWER COLOR COMBINATIONS

Yellow with Red - You project a strong desire to achieve your hopes and dreams and want to make your mark in the world. You can exude a restless urge and spread yourself over too many activities to feel your worth. These colors promote the overachiever syndrome. Wear them to have the courage to stand alone in a new, successful endeavor.

Yellow with Orange - You exude a warm and outgoing nature. You express a talkative nature and are direct and to the point. You project self-confidence and have smart planning and organizational skills. Wear these colors to positively guide children and to stimulate open problem-solving discussions with groups.

Yellow with Green - You are sharply aware and keenly observant of the different opportunities that offer individual freedom and self-growth. You have a strong urge to achieve recognition and self-actualization. You are willing to extend greater understanding between yourself and others. Wear these colors to persuade and guide others toward new ideas and a balanced lifestyle.

Yellow with Blue - You have a desire for contentment and harmony through relationships that are affectionate and promote good will. You project a positive, self-accepting image. You need mutual understanding and warmth from others. You are open to new avenues and ideas that are successful and exciting. Yellow with a deep blue is harmonious in group settings or negotiations, where new ideas or visions about the future is required.

Yellow with Indigo - You have a need to pursue and lead others into new endeavors that provide progressive change. You exude positive assurance and a cheerful attitude toward others. Wear yellow with navy or royal blue to help assist others, especially family members to reach their future goals. Wear pale yellow with navy or indigo in business or professional situations to motivate others and stimulate creative brain-storming for future changes.

Yellow with Violet - You have a need to express your overly active imagination and vivid fantasies through exciting pursuits and the theatrical arts. You seek admiration for a charming and magical personality. You have a bent for metaphysics and are visionary about your future. Wear these colors to motivate others to gain spiritual growth and psychological insights.

Yellow with Brown - You have a desire to happily serve others with physical comforts. You can be mentally obsessive and unyielding in your pursuit to actualize all your plans. You have a need to express your alert and inventive mind in a secure position. Wear yellow with deep brown to project a sharp mind with a stable personality. Wear yellow with tan to express an intellectually friendly and open disposition.

Yellow with Black - You need a drastic change of direction and circumstances to avoid problems and difficult situations. You need to have a greater regard for other's ideas and their feelings. You project a cheerful personality, yet hide your emotions. Wear bright yellow with black to help another make a positive change in their life. Wear golden yellow with black to focus on future career and business success.

Yellow with Gray - You desire a complete and positive change for your future. You approach new situations with caution. You project an open-minded and progressive viewpoint with controlled emotions. Wear all types of yellow with variations of gray to help you and others make important decisions and adjustments to future changes. In professional situations, pale or silvery gray with bright yellow adds a sophisticated, progressive and avant-garde style.

Yellow with White - You have a deep desire to openly express your emotions and your sexuality. You exude warmth and cheerfulness toward others and have a positive attitude toward your future. Wear this color combination to uplift others from the doldrums or when visiting someone depressed or physically ill.

ZODIAC SPECTRUM

The day and month you were born determines your zodiac sign. Your unique planetary portrait reflects the rainbow in specific nuances of each hue.

Aries: lemon
Taurus: golden yellow
Gemini: vivid yellow
Cancer: pale yellow
Leo: bright and golden yellow
Virgo: ocher

Libra: banana
Scorpio: amber
Sagittarius: deep yellow
Capricorn: mustard
Aquarius: tropical yellow
Pisces: pastel yellow

RELATIONSHIPS

LOVE AND ROMANCE

The colors you favor and wear project a particular image to others. They can enhance your personality and affect how you relate to others, especially in your personal relationships.

With a preference for **yellow**, you are intellectually and physically attracted to progressive, healthy, avant-garde types of partners. Your cheerful and friendly nature attracts more romance than you are interested in. You are choosy, preferring someone to match your stride and abundant activities. You need a partner who presses toward the new, the unformed, and the future. Although you are basically a warm, out-going person, you need periodic, if not daily time, to set aside for yourself and recharge your potent energy. Your partner must understand your need to be totally alone when the mood strikes. Mutual intellectual pursuits are required for you and your partner. Your adventurous spirit is experimental in lifestyle and mental interests. You do not like to waste time and require your partner to be just as involved in projects as you are. You cannot tolerate a lazy or laid-back person. You need a mate that is an achiever in their chosen field. Happiness is your motto for relationships.

Bright or Vivid Yellow - You are extremely intellectually active. A mental match is more important to you than a physical one. You demand a vivacious mate who can be involved with your projects and interests as well as their own. You have a positive outlook on your relationship and its progress. You expect changes and growth and accept their occurrence.

Pale Yellow - You prefer a relationship that is less intellectually stimulating but down to earth and mellow.

FRIENDSHIP

Yellow is great for stimulating a lively conversation and a carefree day together. Yellow will uplift your spirits and motivate you to engage in intellectually stimulating activities such as word games and challenges to your memory. It will cheer up a friend and brighten their day with positive thoughts for the future of your relationship. Show your appreciation for your loyal friend and give yellow flowers or a gift for a memorable occasion. Your thoughtfulness will always be remembered.

COLOR HARMONY

Yellow and Red - Both are primary hot colors. They are over stimulating and fight each other for attention. Together their intensity grabs your attention.

Yellow and Orange - are analogous and are a very warm combination. These are the two brightest colors of the spectrum. Together they jump out at you and quickly get your attention, even when they are within your sight but not directly in front of you. They are harmonious in the same tone with either color dominant or if yellow is lighter or dominates the orange. Together they express mental stimulation.

Yellow and Green - This warm and cool combination is analogous to one another. These spring colors decrease depression and create a cheerful disposition.

Yellow and Blue - are both primary colors. Together they create an "in and out" type of movement. Yellow is warm and boldly advances toward you. Blue is passive and recedes into the background, appearing to move backward. Lighter tones of yellow with dark blue create a stronger movement than bright or light blue with deep yellow. Together they express the need for emotional and intellectual attention.

Yellow and Violet - Yellow and violet are complementary and are opposites on the color wheel. They are the expression of the interplay of warm and lukewarm. Pale yellow with medium to deep violet is most becoming. Bright yellow and lavender or lighter violet is less appealing.

Yellow and Indigo - are very clashing together. Indigo contains violet (the opposite of yellow), and will appear more violet next to yellow. Their powerful interplay of advancing (yellow) and receding (indigo) creates a vibrating movement, almost like a strobe light effect.

VEHICLES

The color you choose for a car, boat, bicycle, etc., outwardly reflects your inner needs and personality. Only the color you prefer for a vehicle applies to the information below.

Yellow - is the brightest color of the spectrum and it is the harshest for the eyes to perceive. Because of its remarkable visibility, it is an excellent color for boats and all small vehicles such as motorcycles and bikes. You may prefer yellow strictly for safety measures or for pure taste. Selecting pale yellow or cream, marks you as an intellectual and progressive in style. Yellow assists you in remaining mentally alert and noticeable by others.

SENSES

SOUND - Yellow is the musical note of E. Its cheerful, uplifting music, allows you to experience positive feelings. Happy tunes that make you sing and recall fond memories of the past are yellow in vibration. Its nostalgic melody stimulates your memory of positive past experiences. It will put a smile on your face and put you in a good mood.

TOUCH - Yellow feels warm as an inviting ray of golden sunshine.

TASTE - Yellow tastes salty. It is found in stimulating spices like turmeric, seaweed, and sea salt. It can stimulate your digestion and in greater amounts acts as a laxative. It promotes tissue growth and balances the minerals of the body through retention of water, and relieves muscle stiffness. If used in excess, it can cause an imbalance in the blood and cause vomiting.

VISUAL - Yellow is brighter than white. It jumps out at you. You cannot avoid its loud personality. It stimulates the mind to focus and remember words and numbers (note the yellow notepad's popularity and use). It will attract you and bring attention to itself. Yellow beckons you to think before you act. It is the most difficult color to look at for any length of time.

SCENT - Yellow fragrances are iris, clove and rattan.

FORM - Shape: the triangle relates to yellow.
Line: the jagged line expresses the feeling nature of yellow.

DRAWING EXERCISES

Since ancient civilization through modern times, humankind has utilized symbols to express itself. Symbols are a universal language which conveys specific meanings. One shape can evoke a deep response and express many words.

You have been made aware of how colors relate to shapes. Through the process of creating a triangle, which expresses the specific color **yellow**, you can experience the feeling and energy of that color. You can draw or doodle a triangle on paper, inscribe it in the sand, or in mid-air. Making a triangle will help empower you to achieve the following:
1. to prepare yourself for positive action and projection;
2. to develop memory retention and intellectual learning;
3. to strengthen your mind;
4. to become happy and joyful.

MENTAL EXERCISES

IMAGERY

Think yellow for positive energy, to organize your thoughts, to memorize information, and to make important decisions. Think yellow and enlighten, as well as brighten your path to greater self-fulfilling experiences. Feel its joy and warm stimulation.

MEDITATION

Visualize the warm, golden rays of the sun beaming upon you, engulfing you, penetrating your skin and illuminating your mind. Breathe in the golden yellow rays as they bring understanding and clarity to your consciousness.

SPECTRUM IN GREEN

Green is the color of spring and all abundance of life. It is the essence of life vibrating in growth. Its subtle influence and effect upon you can be used to serve your every need. Add green in your life today.

Green is the combination of the two primary colors, yellow and blue. It is a secondary color and combines the meanings of both colors. Because of the warm and cool colors comprising green, its meaning will vary according to which of the two colors is dominant. Including all the qualities of both yellow and blue, the attributes of green are hope, growth, sustenance, sharing, quieting, refreshing and responsiveness. Its opposite impressions are envy, greed, constriction, guilt, jealousy, terror and disorder. It is the Awakener of Life!

ENVIRONMENTAL EFFECTS

SURROUNDINGS

Surround yourself with green for stability and comfort. Its spring-time quality livens a room like a breath of fresh air. Green is sooth-ing to the eyes and subdues excitation. Accented with lighter tones, it is very pleasing to the senses. Add green and feel re-freshed!

Family - The most commanding of colors, green enables you to have total control over exercising your will-power in difficult situations. Its cooling and healing effects are non-threatening to others. It can bring the family together to work toward mutual, as well as individual goals. Green's giving nature suggests involve-ment with community affairs and sensitivity toward neighbors.

Children - Green creates a pleasant atmosphere where children can interact in a friendly helpful manner. Emerald green encour-ages strength in a frightening situation and enables the child to heal emotional and physical traumas. Its influence can help a child develop self-pride and adaptability.

Pets - Grass green and bright green shades give the appearance of the outdoors in a pet's room. It can feel refreshing and always seem clean and sterile. Green can normalize and stabilize the health and physical activities of the animal.

LIGHTING

Clear green light enhances a meal. Avoid yellow-green; it is very unappetizing. Plant growth is greatly inhibited with green lighting.

PHYSICAL EFFECTS

HEALTH

Green, with its regenerative and balancing qualities, is the master healer, especially the emerald and bluish hues. It assists in dissolving blood clots, builds the muscles, tissues, and skin, and breaks up congestion. It helps eliminate germs, viruses, and toxic wastes. It gently brings restoration and balance to the entire body.

FOOD AND NUTRITION

Eat green vegetables and fruit for vitamin C and rich minerals. The more saturated and brighter the green, the more nutritional value in the content of the food. Green garnishments (parsley) and accessories (napkins, tablecloth) add in creating a wholesome appetite and natural environment for dining.

PHYSICAL EXERCISE

Green's cooling properties and balancing nature promote health maintenance. Promoting longevity, it is the best color for mature adults with health problems to wear or be surrounded by, especially when exercises are performed for the improvement of specific areas of the body. Green will allow maximum performance for the individual without harm or damage to a weak area of the body. The emerald, aqua and turquoise tones give a youthful feeling to the body and instill a hopeful attitude for progress and positive projection of a healthier body. Use green and be rejuvenated.

PERSONAL EFFECTS

If your favorite color is green, you like to impress others and be in command of most situations, especially in a position of power. You tend to be helpful, tenacious, and persevering with important relationships. Adaptable and flexible in nature, you try to maintain self-control and a friendly disposition. You are proud of your accomplishments and require recognition for them. The purer the hue, the more stable you are. Your inner urge is to remain close to nature and participate in the dance of life and its celebration, through experiencing prosperity and abundance in mind, body, and spirit.

FASHION

Wear green to be in command of a situation, to use your will-power, and to harmonize your entire self. Its balancing properties are comfortable in all seasons. It greatly improves your health.

BEAUTY - PALETTE - Colors enhance your total appearance, especially when they are harmonious with the shade of your hair.

Pale Blonde: All shades of green, aqua and turquoise
Dark Blonde: Medium to dark shades of all green hues are best
Red and Auburn: All greens are ideal; especially emerald
Light Brunette: Olive is appealing, avoid light shades of green
Dark Brunette and Black: Bright green; avoid pastel green
Gray and White: Turquoise and aqua

JEWELRY - Green gems promote well-being and abundance. Examples: emerald, jade, aventurine and malachite.

CAREER-FASHION

Green is the best color for the teaching and healing professions. It not only commands attention, but also refreshes the mind and body, allowing you to appear alert and fresh as a spring breeze. It has great appeal for restaurant attendants, waiters and waitresses. Projecting an earthy quality, it also suits people involved in outdoor occupations connected with nature. Green conveys the spirit of life, prosperity and will-power. Use it to your advantage and also reap the soothing benefits personally by wearing it or having it in your work-space. Green will keep your nerves calm and your body rejuvenated all day, especially in high stress positions. Wear green and feel refreshed.

THE POWER OF GREEN

Green is the color of will-power and self-determination. Green helps you overcome opposition and remain independent in spite of difficulties. Green spurs you on to recognition and achievement. Green is commanding without being demanding.

Mint is a pastel and **sea green** a tint of green. You need to maintain a sense of well-being even under negative circumstances. You project a gentle and mellow nature. Green tints evoke a steady commitment to projects and relationships.

Forest green is a shade and **olive green** is a tone of green. Forest green - You are deeply committed to your word or promises made. You project a love for nature and traditional family values and relationships. You are reliable and can shoulder difficult responsibilities with a calm mind and self-assurance. Olive - You approach life with a narrow viewpoint or a one sided vision. You are prudent and contrived to a fault. You camouflage your true feelings behind a quiet and conservative personality.

POWER COLOR COMBINATIONS

Green with Red - You have a need to be independent and self-oriented toward success. You try with great force to overcome all obstacles and to make proper decisions pursuing your objectives. You can put your nose to the grind stone and single-handedly accomplish your tasks. A great combination for physical outdoor work, such as yard work or gardening.

Green with Orange - You desire a friendly and warm relationship that allows you to exercise your free-will. You project a mature adventurous and gregarious spirit. Wear mint green with coral, peach or salmon to harmonize your mind and body. You project concern for the total welfare of others. For selfless acts toward others wear deep green with peach tones.

Green with Yellow - You have a need for popularity and admiration for your impressive ambitions. You express a harmonious nature in your attempt to bridge the gap between you and others. Wear deeper tones of green with golden yellow to successfully instruct others on new projects.

Green with Blue - You sensitively express your individuality for acknowledgment. You want to make a favorable impression and receive proper recognition for your abilities and talents. Wear these colors to influence others in a group or family setting.

Green with Indigo - You have a need to exercise your will-power and be heard in family matters and groups. You project a cool, calm disposition with quiet self-assurance. Wear emerald green with royal blue and vivid indigo in the healing and health care professions for physical balance and soothing mental calmness. Wear deep or forest green with bright indigo for teaching others and to gain positive control over a group.

Green with Violet - You are original and have a need to impress upon others that you are a special personality. You desire special recognition and influence through being in control of situations.

Wear deep rich greens, especially emerald green with lavender or or deep violets to balance your physical body and your psyche.

Green with Brown - You project the ability to overcome difficulties with unwanted responsibilities. You have a need to express your pride and maintain a sense of security. You desire a long-lasting love or marriage and wealth. Wear deep shades of green with tan or beige for calmness and comfort in long and strenuous group or family activities.

Green with Gray - You have a need to establish yourself, build your self-esteem and make an impression on others despite un-favorable circumstances. You project a cool and calm disposition outwardly, while having mixed feelings inwardly. This combination in all color types expresses a conservative disposition in financial and family affairs.

Green with Black - You express your overwhelming self-will to prove your immense personal power and lack of any weakness. You desire status inwardly, while projecting a conservative and cautious nature outwardly. Wear deep tones of green with black to enlist the help of others to assist you toward a balanced and pros-perous life.

Green with White - You are kindhearted and have a need to nurture and care for others. You exude generosity toward loved ones and care deeply for your family. Love of the family and pros-perity are important to you. Wear light greens with white for mutual tender care and contentment at home.

ZODIAC SPECTRUM

The day and month you were born determines your zodiac sign. Your unique planetary portrait reflects the rainbow in specific nu-ances of each hue.

Aries: vivid green
Taurus: emerald
Gemini: aquamarine
Cancer: sea green
Leo: metallic green gold
Virgo: olive and avocado

Libra: mint green
Scorpio: forest green
Sagittarius: turquoise
Capricorn: ivy green
Aquarius: iridescent green
Pisces: pastel sea green

RELATIONSHIPS

LOVE AND ROMANCE

The colors you favor and wear project a particular image to others. They can enhance your personality and affect how you relate to others, especially in your personal relationships.

If you prefer **green**, you are consistent in your feelings for your partner and require sincerity and honesty at all costs. You extend a generous hand to help your mate in all areas of his/her life. You enjoy a pleasant personality with an even temper and a lot of common sense. You prefer a neat and healthy appearance in your partner. Married green lovers tend to regulate their lives by traditional standards. You like to be active in community affairs, educational groups, clubs, and social organizations. You are sensitive to your neighbors and the community at large. Your partner's social standing, reputation, and financial position are of great importance to you. Your tremendous need for companionship and affection keeps you on the lookout for a prospective partner.

Light Green - You are overly sentimental in romance and need a sympathetic and supportive partner. You prefer a gentle partner.

Emerald Green - You are generous with your time and effort to assist your partner in reaching mutual goals. You prefer a person who is wealthy in character and one who seeks self-improvement.

Teal - You are appreciative of beauty and refinement. You are nurturing and help support your partner's needs and potentials. You prefer a partner who has cultural or educational attainments.

Sea Green - You have strong feelings for your partner, and also tend to endure, even under negative circumstances. Your staying power in the relationship is everlasting (" 'til death do we part"). You strongly uphold traditional values. However, you can be quite envious toward your mate, seeking to find fault or wrongdoing.

Yellow Green/Lime - You can be possessive and unstable in your approach to relationships. Unyielding and tenacious, you tend to create little white lies in order to control your mate. Avoid twisting or stretching the truth. Learn to be a little more vulnerable, especially since you tend to keep the upper hand in the relationship.

Turquoise - Nurturing and maternal in nature, you seek a partner who is strong and forceful, but gentle, emotional and protective inside. You enjoy a sentimentally romantic and refined partner who will share your enthusiasm for all that is beautiful and tasteful.

When married, green lovers tend to regulate their lives by traditional standards. You like to be active in community affairs, educational groups, clubs, and social organizations. You are sensitive to your neighbors and the community at large.Your partner's social standing, reputation, and financial position are of great importance to you. Your tremendous need for companionship and affection keeps you on the lookout for a prospective partner.

FRIENDSHIP

When it seems awkward to ask for a needed favor from friends, use **green** for self-assurance. It will help make you comfortable in approaching them and achieve your expectations. Wearing emerald or bright green is great when visiting a sick friend. Green is ideal for social gatherings where you need to influence others.

COLOR HARMONY

Green and Red - They are opposite in nature and complementary. In this interplay of cool and warm, all shades of pink or tints of rose are the most pleasing with bright green or emerald green.

Green and Orange - This cool and warm combination is clashing and very bright to the eyes. Vivid and deep shades of green and light orange, particularly peach, is very appealing and warm and inviting for the home, office and dining.

Green and Yellow - This warm and cool combination is analogous to one another. These spring colors decrease depression and create a cheerful disposition.

Green and Blue - Both are cool and analogous to one another. Very attractive to the senses, together they create a soothing and healing effect on the mind and body. Dark or deep blue with light green is very balancing.

Green and Indigo - Both are cool and very calming to the senses and are most pleasing and effective when indigo remains dark or deep and green is much lighter. The greater the contrast of light and dark, the more harmonious is the effect.

Green and Violet - They are very clashing unless one hue is significantly darker or deeper than the other. Soft and warm tones of lavender are quite pleasant with clear, bright, and deep green. This combination is mentally healing.

VEHICLES

The color you choose for a car, boat, bicycle, etc., outwardly reflects your inner needs and personality. Only the color you prefer for a vehicle applies to the information below.

Green - is the most soothing color to perceive, especially emerald and vivid tones. Your preference for a green vehicle implies that you are practical and conservative in your approach to operating it. You are cautious in your driving habits and are courteous to other motorists. The more brilliant the green the more self-controlled and determined you are in nature. If you prefer olive and subdued greens, you are most likely not interested in being noticed and are a follower and passive in nature. If you like a green car of this shade, you like your car to blend in with the scenery. If lime green is your selection, you desire to be noticed and enjoy attention.

Neon/Vibrant Green - is one of the most popular new colors. This exciting vivid color is pleasant to the eyes and noticeable in all seasons. A peppy, proud and positive person is attracted to this color. You will literally feel good and exhilarated while driving.

SENSES

SOUND - According to Isaac Newton, the musical note of F is green. Like a breath of spring air, its melody is serene and healing to all of the senses. Pleasant, relaxing harmonies and light, lively rhythms in perfect balance resound to green vibrations.

TOUCH - Cooling to the touch, green appears to feel moist or misty. The darker shades and muted tones feel damp. The brighter and more vivid tones feel like morning dew.

TASTE - Green's astringent quality can be found in unripe bananas, herbs like witch hazel, and aloe vera, and vegetables such as beans and cabbages. It promotes healing of the skin, firms the tissues, provides a mineral supplement, and strengthens mucous membranes. In excessive amounts, it can cause premature aging, muscle spasms, and circulatory problems.

VISUAL - Most soothing to the eyes, green suggests coolness in warm weather and warmth in cool weather. It is restful and pleasant to the body. It gives the feeling of hope, and evokes a sense of well-being.

SCENT - The fragrances of green are musk and spring rain.

FORM - Shape: the hexagon relates to **green**.
Line: the check mark expresses the feeling nature of green.

DRAWING EXERCISES

Since ancient civilization through modern times, humankind has utilized symbols to express itself. Symbols are a universal language which conveys specific meanings. One shape can evoke a deep response and express many words.

You have been made aware of how colors relate to shapes. Through the process of creating a hexagon, which expresses the specific color green, you can experience the feeling and energy of that color. You can draw or doodle a hexagon on paper, inscribe it in the sand, or in mid-air. Making a hexagon will help empower you to achieve the following:

1. to heal and balance your mind, body, and spirit;
2. to obtain prosperity;
3. to begin a new project and exercise your will-power.

MENTAL EXERCISES

IMAGERY

Think green to increase prosperity and to heal your mind, body, and spirit. Green helps you increase self-esteem, and personal power when you are in the role of managing, teaching, or healing others. It empowers you with the will to endure under adverse circumstances. Think green to refresh and regenerate your mind!

MEDITATION

Close your eyes and look to the middle of your forehead with your mind's eye. Now visualize yourself submerged in an emerald green forest surrounding a body of water. Allow the fresh green grass, the deep forest green, and the clear turquoise water to engulf your entire being. Breathe in the refreshing emerald green and feel its soothing vibrations harmonize with your world physically, mentally and spiritually. Now allow its balancing properties to restore, refresh and regenerate your entire being. Feel life pulsating through and around you! Awaken to life!

SPECTRUM IN BLUE

Blue is the color symbolic of heaven. It is timeless beauty in silence as the infinite sky, and gentleness in motion as a calm sea. Its universal appeal creates unity and harmony through its peaceful vibration. Add blue in your daily life for successful personal relationships.

Blue is a primary color coming from itself, and no other color can create it. Its nature is cool and calming, it is passive and receptive in response. Blue is the easiest color for the eyes to perceive. Its attributes are love, acceptance, patience, understanding, and co-operation. Its inhibiting qualities are fear, coldness, self-pity, passivity and depression. Blue is a favorite color among all age groups.

ENVIRONMENTAL EFFECTS

SURROUNDINGS

Blue surroundings calm the emotions, rest the body, and create a sensitive and trusting atmosphere. Lighter tones of blue create a spacious effect and the darker tones a cooling effect. Surround yourself with blue to acquire peace of mind and emotional balance.

Family - Sky blue is excellent for fair and open discussions of a peaceful nature. Deep blue promotes a spirit of compromise and a sense of security. Its harmonious nature brings unity among family members.

Children - The brighter or more vivid the blue, the greater the effects upon the emotions and physical activities of children. As a sedative, it helps a child to sleep after nightmares or a restless, irritated sleep. Physically, the relaxing quality of blue helps to settle down a hyperactive child. It promotes the value of sharing and the spirit of compromising with others. Blue allows the child to learn how to listen and to speak softly and calming. You will find very little shouting among children in a blue room. Its cooling atmosphere can help inhibit temper tantrums and violent emotions.

Pets - Blue has a great calming effect upon a traumatized animal. It will also promote harmony among pets and family members. The deeper shades of blue have a tranquilizing effect on animals. It will help slow down an overly aggressive pet.

LIGHTING

Blue lighting in a room inhibits activity and gives a subdued atmosphere. It is very undesirable for dining, it slows down the metabolic processes, giving the food an unappetizing appearance. It is ideal for the bedroom, since it creates a relaxing and peaceful atmosphere. Indoor plants grow smaller in size and exhibit less vitality with blue lighting.

PHYSICAL EFFECTS

HEALTH

Used for fevers, and to normalize a fast pulse rate, **blue** also acts as a pulmonary sedative, depressing the motor nerves, and combating infection. It encourages relaxation, and subdues physical and mental disorders. Among its many cures are sore throats, laryngitis, hoarseness, dysentery, jaundice, cuts, burns and bruises.

FOOD AND NUTRITION

Blue is an excellent background to display foods harmoniously and pleasingly. It has a slowing down effect upon the metabolism and visually enhances the taste of a meal.

PHYSICAL EXERCISE

Blue is an excellent color for body building and expanding your muscles to gain bulk. It helps you maintain a slow and steady pace for all physical activity. It is especially wonderful for yoga exercises where breathing and movement are synchronized for mental and physical balancing.

PERSONAL EFFECTS

If you favor **blue**, your devotion to a person or cause is relevant. Your spiritual beliefs and moral principles are very important to you. You need relationships for emotional security and inner harmony. You tend to be peaceful and reflective with a nature requiring an orderly existence. You are somewhat introverted and introspective. Your greatest traits are sincerity, diplomacy and responsibility.

FASHION

Blue gives a youthful appearance to the skin, brings out your charming and pleasing nature, and improves self-moderation and self-assurance. Wearing blue relaxes the entire body and has an equalizing effect on your energy.

BEAUTY - PALETTE - Colors enhance your total appearance, especially when they are harmonious with the shade of your hair.

Pale Blonde: Azure, and all shades of blue
Dark Blonde: Bright shades of blue
Red and Auburn: Bright medium blue
Light Brunette: Avoid pale blue, deep blue is best
Dark Brunette and Black: Cobalt and Navy blue, avoid light blue
Gray and White: Cerulean and electric blue

JEWELRY - Blue gems strengthen emotional balance, inner security, and improve your mental and spiritual self. Wear a blue gem to enhance your appearance. Examples: sapphire, turquoise, and aquamarine.

CAREER-FASHION

Blue is best for the mediator, counselor, group director, or any position where one has to be diplomatic and compromising. It will benefit you greatly in almost any situation of power that requires a moderate approach toward subordinates. Blue helps you say the right thing at the right time. It's good for committee work especially with large organizations.

THE POWER OF BLUE

Blue is the relationship color. You express a serene, peaceful and harmonious nature with a desire to compromise with others. You regard other's needs and desires as equally important to your own. Mutuality and gentle persuasion are your keys to success.

Powder blue (faded blue jeans) is a pastel and **robin's egg blue** is a tint of blue. You express a desire to involve yourself in a new relationship or a group endeavor. You evoke an open and compromising spirit and use gentle persuasion. White with a tinge of blue is the most romantic color to wear. Wear robin's egg blue to build self-confidence and to express a charismatic presence.

Cobalt blue is a shade and **country blue** is a tone of blue. You are in spiritual search for inner harmony and a lasting commitment to a person or a religious cause. You evoke sincerity, mutual under-standing, a calm and controlled disposition. Wear dark or deep blues to promote fair negotiations and for harmony and fairness in family or group counseling.

POWER COLOR COMBINATIONS

Blue with Red - You express a desire for a harmonious, affectionate and compatible relationship. You project a loving, trusting and self-sacrificing nature. Wear matching combinations when working with the public or peacock with rose when romancing your loved one.

Blue with Orange - You express a kindly disposition and are able to compromise with others for mutual goals. You are trustworthy and sincere in friendship. You desire a mutually caring and sharing equal relationship. Wear aqua with light peach or coral to balance your personal needs with those of others.

Blue with Yellow - You project emotional enthusiasm. You are willing to adapt to another's needs with mutual understanding and consideration. You desire happiness and fulfillment through an intimate or group relationship. Wear matching combinations to harmoniously work with others toward a mutual goal.

Blue with Green - You project a peaceful, stress-free and responsible nature. You are sensitive to the feelings of others and are observant with an eye for detail. Wear any matching tints or shades of blue and green to balance your physical body and to calm your mind. The deeper hues are an excellent combination when dealing with others in a highly stressful or tense situation.

Blue with Indigo - You have a need for rest and tranquillity. You express a complacent and compromising nature.Wear peacock or aqua with royal blue or bright indigo to project a sense of beauty and harmony. This combination is popular and attractive for professionals and mediators dealing with groups.

Blue with Violet - You express tenderness and emotional sensitivity in an intimate relationship. You are very responsive to beauty and romance. You have a need for a deeply committed relationship. Wear aqua or teal with purple for involvement with creative or artistic projects. Wear lavender with peacock or cobalt blue to express your desire for a faithful commitment and for participation in a spiritual group meditation /prayer.

Blue with Brown - You express outward indifference while inwardly are warm and very lustful or romantic. You have a need to feel fully accepted before you break down your barriers and let someone into your heart. The darker hues project a fear of separation and loneliness. Wear light aqua, teal, or peacock with tan or beige in situations where acceptance, nurturing and warmth are needed toward and from others.

Blue with Black - You desire to avoid intolerable circumstances that lead to separation from others. You have a deep desire for peace, affection, consideration and relaxation at all costs. Wear deep blue or cobalt with black when you are in a safe place to completely relax and let down your guard.

Blue with Gray - You desire companionship and interaction with others to replace boredom or a lack of personal interests. You project a secure personality, while underneath you are indecisive and unsure of yourself. Wear peacock blue with gray in business or group settings that require good judgment and objectivity. Wear dark blue with silvery gray in professional situations where you are the mediator or negotiator for a group such as a union steward.

Blue with White - You project a charismatic, inspiring, and self-reliant nature with the ability to learn from your past. You are motivated to achieve your goals. You desire admiration for your authority and can be self-righteous. Wear peacock or light blues for self-confidence and to have a positive influence on others.

ZODIAC SPECTRUM

The day and month you were born determines your zodiac sign. Your unique planetary portrait reflects the rainbow in specific nuances of each hue.

Aries: azure blue
Taurus: powder blue
Gemini: sky blue
Cancer: gray blue
Leo: bright blue
Virgo: ultramarine

Libra: peacock blue
Scorpio: sapphire blue
Sagittarius: cerulean blue
Capricorn: navy blue
Aquarius: electric blue
Pisces: pastel blue

RELATIONSHIPS

LOVE AND ROMANCE

The colors you favor and wear project a particular image to others. They can enhance your personality and affect how you relate to others, especially in your personal relationships.

Lovers who favor blue like relationships that are equal, harmonious, and tension-free. You need a partner who is loyal and true blue to you. You are tender and quietly temperamental, yet moody. You also require a spiritual union and like to feel settled, united and secure with your partner.

Pale Blue - You will weather a relationship with severe ups and downs. You try your best to compromise with your differences.

Medium Blue - You will work harder at the relationship than your partner. Harmony and peaceful relating is important to you. Compromise is your strongest quality.

Aqua - Nurturing and maternal in nature, you seek a partner who is strong and forceful, but gentle, emotional and protective inside. You enjoy a sentimentally romantic and refined partner who will share your enthusiasm for all that is beautiful and tasteful.

Deep Blue - You are content in relationships that strive for fulfillment and mutual satisfaction. You need a deep relationship with a sincere and spiritual connection.

Blue creates the mood for soft conversation and gentle persuasion. It enhances one's feeling of belonging and contentment. The deeper the blue, the stronger the commitment between two people. The pale or light blues are more superficial in nature and express the early stages of involvement. Blue is the ideal atmosphere for a quiet evening of intimate sharing.

FRIENDSHIP

The spirit of compromising among each other and the development of a fair relationship can be formed. Blue is great for a relaxing evening or just being together and sharing.

COLOR HARMONY

Blue and Red - Both are primary colors and have opposite effects, cool and warm. This color combination is a favorite among most folks. Each color fights for attention, yet balances the other. Pink with dark blue, and deep red with light blue are most harmonious in combination.

Blue and Orange - They are opposite in nature and complementary. This interplay of cool and warm attract greatly. One color or the other should dominate in order to create greater harmony. Peach and deep dark blue is a pleasing complement.

Blue and Yellow - The combination of these primary colors creates much attention. Lighter tints of yellow are best with different shades of blue.

Blue and Green - Both are cool and analogous to one another. This harmonious combination is very attractive to the senses. In combinations they create a soothing and healing effect on the mind and body. Dark shades of blue with light tints of green are very balancing.

Blue and Indigo - These colors are analogous to one another. Blue, as a primary color, is stronger than indigo, which contains blue. Together they are very cold and passive in nature. However, they are both calming to the senses and have a great tranquilizing and soothing influence. They are best used together in any shade or tint as a body relaxer and to induce a deep sleep.

Blue and Violet - The cool and lukewarm properties of blue and violet are analogous to one another. They create positive effects on the mind, spiritual self, and the emotions. They work best as a sedative to relax the mind and body.

VEHICLES

The color you choose for a car, boat, bicycle, etc., outwardly reflects your inner needs and personality. Only the color you prefer for a vehicle applies to the information below.

Blue - is the most pleasing color to the eyes and one of the most popular color choices for a car or boat. It has one of the slowest vibrations in the spectrum; as a result, blue vehicles give the optical illusion of moving slower than they actually are. If you prefer the vivid or neon metallic blue for a vehicle, you have an eye for beauty and taste. Selecting a deeper or more subdued blue reflects your need for a calm, relaxing experience while operating the vehicle. Preferring powder blue or light metallic blue, you are complacent and passive in nature. You don't like to be in a rush and would rather patiently take your time. In general, selecting blue indicates a need for belonging and emotional security.

Neon/Vibrant Aqua - is one of the most attractive colors as well as easy to see in all weather conditions. You are a lover of beauty and design and appreciate all the wonderments of life. This is a popular color choice for the poised and gracious driver.

SENSES

SOUND - Blue is the musical note of G. Soft and slow melodic music vibrates the color blue. Its effects are soothing, dreamy, and relaxing. Blue evokes thoughts and deep emotions. It is very healing in effect, by slowing down the heart rate and calming the nervous system.

TOUCH - Blue is soft as a cloud and transparent and smooth as a wave in water. Its sensation is moistness.

TASTE - Blue is very sweet, as found in sugars and sweet herbs. It promotes growth, contentment, and strength. In excess, it can lead to overweight and inhibit digestion.

VISUAL - Blue is the most pleasing color for the eyes to perceive. It is a favorite color choice among all ages, especially bright blue for babies. Blue is cool, peaceful and tranquil to the eyes.

SCENT - The fragrances of blue are magnolia and orange flower.

FORM - Shape: the circle relates to blue.
Line: the horizontal line express the feeling nature of blue.

DRAWING EXERCISES

Since ancient civilization through modern times, humankind has utilized symbols to express itself. Symbols are a universal language which conveys specific meanings. One shape can evoke a deep response and express many words.

You have been made aware of how colors relate to shapes. Through the process of creating a circle, which expresses the specific color blue, you can experience the feeling and energy of that color. You can draw or doodle a circle on paper, inscribe it in the sand, or in mid-air. Making a circle will help empower you to achieve the following:
1. to relax your body and calm your emotions;
2. to reach a solution to a problem;
3. to become patient in an overbearing situation;
4. to maintain spiritual development.

MENTAL EXERCISES

IMAGERY

Contemplate blue to acquire inner peace, to relax the body, and to soothe the mind. Feel your entire self become emotionally balanced.

MEDITATION

Close your eyes and imagine yourself floating in the air. Absorb the cool and calming blue sky into yourself. Breathe its peaceful vibrations and allow your skin to absorb its cooling, cleansing, and purifying effects into every cell. Be calm and at peace.

SPECTRUM IN INDIGO

Indigo is the color of the night sky, the reflection of timelessness-the essence of space. It is symbolic of the balancing scales of life, creating order and harmony within the universe. As a force of pure ideal love, its vibration links all humanity as one. Its gentle effects upon your daily life create trust, understanding, and affection toward others.

Indigo is the combination of the primary color blue and the secondary color violet. It contains the cool elements of both. Its positive effects are humanitarianism, unity, inspiration, synthesis, and balance. Its opposite effects are separatism, rigidity, pride, arrogance and deceit. However, its greatest effect is the creation of harmony between your thoughts and your emotions, which has a direct balancing effect on your decision-making and problem-solving abilities.

ENVIRONMENTAL EFFECTS

SURROUNDINGS

Surround yourself with indigo for emotional tranquillity and to create harmony among family members and groups. It is an excellent color to help restore your health and to recover from physical pain or a severe operation. It is the color best suited for emergency rooms where the injured person needs a soothing atmosphere.

Family - Indigo is ideal for truthful and intimate sharing. It is exceptionally fine for place settings at the dining table, to create a pleasant atmosphere and peaceful interacting among family members. Deep indigo bedroom accessories induce a somewhat calming sleep.

Children - Deep tones of indigo are best for the bedroom to inhibit nightmares and restless sleep patterns, as well as sleepwalking. This is not a favorite color for most children. It is preferred by the religious or spiritually enlightened teenager. Beneficially, it helps develop a conscience and sound judgment.

Pets - Bright indigo is best suited for a hyperactive pet who requires more sleep or rest, especially when recovering from sickness or an operation.

LIGHTING

Indigo is too dark and hypnotic in effect for most surroundings. It is best suited for the bedroom, where its tranquil qualities provide a deep relaxing sleep. It normalizes the growth patterns of plants.

PHYSICAL EFFECTS

HEALTH

Indigo purifies the blood stream, treats acute bronchitis, convulsions, nervous ailments, lung and nasal disturbances, and tonsillitis. As a sedative it is helpful for hemorrhages and internal bleeding. As an astringent it is useful for tightening and toning the muscles, nerves, and skin.

FOOD AND NUTRITION

Eat indigo fruit or eggplant for vitamin K. Indigo is an excellent background color to display foods harmoniously and creatively.

PHYSICAL EXERCISE

Indigo is most beneficial for the cool-down exercises after working out strenuously. It is perfect for sedate and mental exercises requiring slow and concentrative effort. It helps tone muscles, calm nerves, and tighten skin. It is best used for most water sports and physical activities that require common sense and calm thinking to avoid injury to the participant. It gives the mental readiness to partake in dangerous sports where proper and safe responses, not emotional reactions, are required.

PERSONAL EFFECTS

If indigo is one of your favorite colors, its cooling nature reveals your inner need to sustain an idealized sense of harmony with yourself and in your important personal relationships. You possess a very logical mind, you are discriminating and have great mental abilities. Your unselfish expression of creativeness and enthusiastic nature toward the development and attainments of others marks you as a respected and admired leader among groups. Your affectionate nature is strongly in need of a warm, intimate relationship in an atmosphere of sensitivity, love, peace and beauty. You will not compromise your ethics or principles, but you will influence others to your side through loving understanding and unselfish efforts. Harmony with everyone is your greatest asset.

FASHION

Wear **indigo** to feel secure, to recuperate from exhaustion, and to maintain a calm disposition. It will create an impression of compromise and fairness. Indigo portrays a conservative and serious image.

BEAUTY-PALETTE - colors enhance your total appearance, especially when they are harmonious with the shade of your hair.

Pale Blonde: Periwinkle , navy blue and slate blue
Dark Blonde: Bright indigo violet and navy blue
Red and Auburn: Medium and vivid indigo, royal blue
Light Brunette: Bright indigo is most striking
Dark Brunette and Black: Navy blue, indigo light/deep tones
Gray and White: Periwinkle, bright indigo, avoid dark shades

JEWELRY - Wear an indigo gem to express loyalty and devotion to a loved one. Give one to someone you love to create a lasting union. Example: sapphire.

CAREER-FASHION

Indigo is excellent for most traditional and conservative formal dress. The business person, counselor and all occupations that require close working relationships with others, especially intimate ones, are best suited for indigo dress. Indigo gives the image of a serious and responsibly caring person. Members of the clergy, psychologists and teachers need this color for their own stability and peace of mind.

THE POWER OF INDIGO

Indigo represents humanity, groups, organizations and multiple relationships. Indigo stimulates the super-conscious, your connection to a universal source, to all humanity. You are a person of honor, dignity and are highly principled. You live your inner truth and follow your own path of power. Indigo has the most tranquilizing affect on the mind and body. Wear indigo for harmony and success with groups or causes.

Periwinkle is a pastel and **baby blue** is a tint of indigo. You need to experience your connection to your Higher Self, the Divine spiritual power within you. You project a sincere and conscientious attitude. Soft indigos indicates honor and justice.

Navy and **royal blue** are shades and **slate blue** is a tone of indigo. You are spiritually inspired and are loyal and devoted to a cause or humanitarian group. Dark indigos indicate contentment and tranquillity. You are happy remaining with the status quo.

POWER COLOR COMBINATIONS

Indigo with Red - You have a desire for an intimate relationship with reserved passion. You project a trustworthy and fair disposition. You are enterprising with group or corporate goals. Wear navy with red in professions that require impartiality and responsible leadership. Wear royal blue with pink to project your love and devotion to family members or a group.

Indigo with Orange - You have a need to be included in all family or professional activities. You project a reserved nature with an inner urge to befriend everyone. Wear navy with rust color to project an image of fidelity and trust to a person or cause.

Indigo with Yellow - You desire to explore futuristic ideas and alternative group lifestyles. You project an intuitive, witty, and philosophical nature. Wear navy with pale yellow for group brainstorming and to lead others into future changes and experiments.

Indigo with Green - You need to preserve marriage and family traditions. You project a well-rounded and considerate nature with a serious approach to long-term relationships. Wear royal blue and green in group negotiations and for financial planning.

Indigo with Blue - You desire to blend in with all groups and have a utopian attitude about life. You project a very trustworthy and loyal nature toward others or a cause. Wear deep indigo with peacock blue to express charismatic leadership in a group.

Indigo with Violet - You have a great need to live your spiritual ideals. You project a universal image, unbiased with total love for all humanity. Wear indigo with lavender for spiritual meditation with your partner or to review your future projects. Wear violet or deep purple with indigo for a religious or spiritual celebration.

Indigo with Gray - You have a need to become realistic and avoid a spacy outlook. You project a reserved and detached disposition. Wear deep indigo or navy with silvery gray in professional situations to unify others' ideas and to plan objectively for the future.

Indigo with Brown - You have a need for marriage and long-term friendships. You are friendly to everyone in a reserved and calm fashion. Wear indigo and tan /beige for congenial group activities. Wear navy with beige for business negotiations that require a complacent attitude and understanding of all parties involved.

Indigo with Black - You have a desire to retreat from the everyday world and seek solace and inner peace. You project the image of an aloof and detached recluse. Wear deep indigo and navy with black at funerals or in situations where you have a great need to calm nervous tension or to counteract insomnia.

Indigo with White - You desire to start a fresh new life. You project a philosophically pure nature and an idealistic attitude toward future changes. Wear deep indigo or navy and white when in groups and gatherings that require you to get along well with everyone.

ZODIAC SPECTRUM

The day and month you were born determines your zodiac sign. Your unique planetary portrait reflects the rainbow in specific nuances of each hue.

Aries: bright cobalt indigo
Taurus: light indigo, periwinkle
Gemini: bright cobalt indigo
Cancer: light indigo violet
Leo: royal blue
Virgo: navy

Libra: pastel indigo
Scorpio: slate and deep indigo
Sagittarius: pure indigo
Capricorn: grayish indigo
Aquarius: iridescent blue indigo
Pisces: iris blue

RELATIONSHIPS

LOVE AND ROMANCE

The colors you favor and wear project a particular image to others. They can enhance your personality and affect how you relate to others, especially in your personal relationships.

You are very affectionate and deeply devoted to your partner. A bit idealistic in your approach, you need a peaceful and understanding mate. You give love unconditionally as well as enthusiastically. You need a sensitive person who is capable of warm intimacy, uncritical in nature, and sympathetic to your needs.

FRIENDSHIP

Your most intimate sharing and understanding of friends is experienced. You can reveal painful truths of your character in a loving, warm and non-judgemental setting. **Indigo** helps give moral support in very difficult and trying situations.

COLOR HARMONY

Indigo - is a major color in the spectrum of light and is not a primary pigment of the color wheel. Indigo is a highly contrasting and complementary color with most pastel tones of most colors. It is most pleasing when it is the dominant color with green tints, soft pink, peach, pale yellow, blue tints and soft violet tones. In pastel form indigo appears best with blue and violet shades.

Indigo and Red - These colors are a harmonious match, especially since indigo contains a small amount of red. The fire quality of red and the cold receptive nature of indigo balance each other. Rose pinks are very appealing with indigo. However, light indigo and bright red are not too appealing as red appears stronger and is noticed first. Indigo quietly appears passive. Perceptually you might think that indigo has more depth and red more appeal.

Indigo and Orange - They are an unusual combination as both contain red. However, red is a dominant color in orange, and a minor color in indigo. Therefore, orange is dominant and indigo passive. Indigo in small amounts is a strong accent color to orange.

Indigo and Yellow - Both are very clashing together. Indigo contains violet, the opposite of yellow, and will appear more violet next to yellow. Their powerful interplay of advancing yellow and receding indigo create a vibrating movement, almost like a strobe light effect.

Indigo and Green - Both cool and very calming to the senses, they are most pleasing and effective when indigo remains dark or deep and green is much lighter or pure in hue. The greater the contrast of light and dark, the more harmonious the effect.

Indigo and Blue - These colors are analogous to one another. Blue, as a primary, is stronger than indigo, which contains blue. Together they are very cold and passive in nature. However, they are both calming to the senses and have a great tranquilizing and soothing influence. They are best used together in any shades or tints as a body relaxer and to induce a deep sleep.

Indigo and Violet - are analogous to each other as both contain the colors red and blue. Indigo has more blue, and violet has more red. Together they are very harmonious in all tones. Both appear to recede, although purple will appear to advance ahead of indigo because of its red influence. Together they express deep contemplation and are very healing to the mind and its mental functioning.

VEHICLES

The color you choose for a car, boat, bicycle, etc., outwardly reflects your inner needs and personality. Only the color you prefer for a vehicle applies to the information below.

Indigo - Navy and recently vivid cobalt blue with a violet cast describes the indigo found in vehicles. Usually this is selected as a trim or accent color to boats, aircraft, bicycles, etc. If you prefer this deep rich hue, you are ultra-conservative and responsible in nature. You are proud and take exceptional care of your car, etc. You also exhibit refined skills and in-depth knowledge about your care, etc. Your need is to enjoy and appreciate everything to its fullest.

SENSES

SOUND - Indigo is the musical note of A. Its melody is emotionally soothing and spiritually moving. Classical, religious hymns, and sentimental love songs resound the color indigo. This musical hue opens your heart, mind, and soul to your ideals. Its deeply felt message has universal appeal and is understood and enjoyed by all cultures and religions. These melodies can move you to tears of joy, love, or oneness with the Divine. It can awaken you to your most treasured desires and inner needs.

TOUCH - Indigo has the appearance of extreme coldness, like the crystalline ice of outer space.

TASTE - Indigo is balanced between sweet and bitter. It is a normalizer of taste. It is almost tasteless. Indigo vegetables are rich in vitamin K and improve eyesight and inner sight. Indigo acts as a sedative and improves nervous ailments. In excess amounts it inhibits reasoning ability and proper visual judgment.

VISUAL - Indigo is deeply soothing and peaceful to the mind. It appeals to your logical reasoning ability and intellect. Hypnotic in effect, indigo triggers vivid memories from your past, possibly even past lifetimes. It is the ideal hue for deep, relaxing sleep and inner tranquillity.

SCENT - The fragrances of indigo are cinnamon and lavender.

FORM - Shape: the crescent relates to indigo.
Line: the wavy line expresses the feeling nature of indigo.

DRAWING

Since ancient civilization through modern times, humankind has utilized symbols to express itself. Symbols are a universal language which conveys specific meanings. One shape can evoke a deep response and express many words.

You have been made aware of how colors relate to shapes. Through the process of creating a crescent, which expresses the specific color indigo, you can experience the feeling and energy of that color. You can draw or doodle a crescent on paper, inscribe it in the sand, or in mid-air. Making a crescent will help empower you to achieve the following:

1. to create balance and harmony between thoughts and emotions
2. to become receptive to others and Divine guidance;
3. to develop spiritual understanding;
4. to become deeply relaxed.

MENTAL EXERCISES

IMAGERY

Visualize indigo to make logical decisions, to handle material affairs efficiently, and to induce a deep, relaxing sleep. Feel its tranquil vibration and become mentally balanced.

MEDITATION

Feel an indigo light penetrate gently at the middle of your forehead. Now sense your universal connection with all humanity; feel the unity and oneness of all living beings. Absorb the vibration of ideal, unconditional love. Read your inner wisdom. Now you are one with the Creator. Feel the love.

SPECTRUM IN VIOLET

Violet is the inspirational color of the artist, the mystic and the most refined in character. Its majestic and spiritual power symbolizes nobility and royalty. It is the essence of patience progressing through time. The daily use of violet can create intuitive and sensitive understanding in all your affairs.

Violet is a secondary color comprised of red and blue. It contains qualities of both these primary colors. Its nature is regal and magical as it stimulates the imagination and creative playfulness in you. The more red tones are magnetically vibrant and festive. The blue tones are intuitive and sensitive in expression. Violet's positive attributes are justice, responsibility, mercy, devotion and wisdom. Its opposite impressions are intolerance, obsession, martyrdom, punishment and retribution. Its greatest expression is individualism and universal love.

ENVIRONMENTAL EFFECTS

SURROUNDINGS

Add tints of violet and purple to your surroundings for a soft touch, refinement and to enhance aesthetic beauty. Deeper and richer shades of violet are conducive to altered states of awareness and are best for a religious setting or meditation room.The warmer tones with more red stimulate creativity and enhance vivid fantasizing. Use magenta for sparkle and charm, and to create a festive atmosphere. Magenta is ideal for most celebrations.

Family - Warm shades of violet give spiritual strength and guidance to family members. Violet portrays a dignified and creative parent who allows room for the family's creative expansion and development. Purple and lavender evoke creative problem-solving and free the mind from worry and despair.

Children - The livelier tones and warmer shades stimulate a child's rich and expansive imagination and help to develop an appreciation for the arts and the finer qualities of life. Warm tints of lavender are great for a classical education, to enhance creative learning and natural talents.

Pets - Lavender is favored for the adornment of most animals. Its androgynous quality and beauteous nature is appealing. The deep violet is best used as a surrounding color or bedding for new pets, especially puppies, kittens, etc. It helps settle their fears and feel more comfortable with the unfamiliar new home. They will experience a more restful sleep and won't cry as much. Violet can also aid in teaching animals word commands.

LIGHTING

Violet lighting is not harmonious for dining; however, it's ideal for the bedroom to promote a sound and restive sleep. Violet stained glass windows are inspirational in a spiritual setting. Plants are energized by ultra-violet light, and show balanced growth patterns.

PHYSICAL EFFECTS

HEALTH

Violet is used for bladder trouble, concussions, epilepsy, kidney ailments, neuralgia, nervous and mental disorders, rheumatism, sciatica, scalp and skin disorders. It also induces a deep, relaxed sleep and maintains the potassium-sodium balance in the body.

Magenta is best for heart disorders, kidneys, and emotional balance. It acts as a diuretic, and normalizes the blood pressure.

FOOD AND NUTRITION

Eat violet fruits and vegetables for vitamin D. Grapes, plums, elderberry and purple cabbage are some of nature's delicious and nutritious purple pleasures.

PHYSICAL EXERCISE

Violet has a sedative effect. Therefore, it is best utilized for the last performance of a dance routine or any type of physical activity needing aesthetic appeal. Since it will stimulate your imagination, wear it for boring physical and monotonous routines, where your mind can safely wander. It is the best color for isometrics and slow, deliberate movements such as Tai Chi. It is ideal for posture and yoga meditation.

PERSONAL EFFECTS

If you favor the violet hues, you are a seeker of philosophy and truth. You are dignified and charming toward everyone and follow your intuition over logical thinking. Desiring a magical or mystical relationship, your creative sense is tremendous and your imagination is seemingly real. All the arts are appealing to you, and you have the energy required to participate in them enthusiastically and with much dedication. Possessing many unique qualities, you are the true romanticist and idealist as you develop perfection in your affairs. Your affectionate nature endears you to everyone. You are a king or queen in your place of life's treasures. You are the jewel!

FASHION

Wear **violet** to endure an undesirable situation with inner strength, and to reflect a noble or genuine character. Wear magenta or purple to express the unique and fascinating aspects of your personality and to increase your personal magnetism.

BEAUTY - PALETTE - colors enhance your total appearance, especially when they are harmonious with the shade of your hair.

Pale Blonde: Lavender and soft pastels
Dark Blonde: Light purple and light magenta
Red and Auburn: Lilac and all soft tones of violet
Light Brunette: Violet and deep purple
Dark Brunette and Black: All shades of purple and violet
Gray and White: Orchid, lilac, lavender, and mauve

JEWELRY - Wear violet and lavender gems to increase spiritual awareness, to enhance creativity, and to promote peace of mind. Example: amethyst.

CAREER-FASHION

Purple and magenta are best suited for creative and artistic occupations such as cosmetology, acting, music, the arts, child-care workers, and most positions that require free expression and an intellectually creative atmosphere. The warmer purples and soft tones can be an accent to any outfit, adding charm and a bit of originality to your appearance. Lilac portrays a delicate and sensitive nature.

THE POWER OF VIOLET

Violet is the color of creative imagination, romantic charm and personal magic. Purple and violet stimulate your intuition and spiritual awareness. You have a need to stand out as a unique individual. You are super sensitive, metaphysical and seek identification with a spiritual cause or artistic community. Wear violet to express nobility, dignity and to receive special recognition.

Lavender is a pastel and **orchid, lilac** and **purple** are tints of violet. You are extremely sensitive and somewhat eccentric with a rich imagination. The supernatural and other worlds interest you. You project a sense of personal magic and quiet charisma. You follow your intuition over logic. Wear tints of lavender for a deep spiritual meditation and when you desire loving acceptance for your unique qualities.

Mauve and **mulberry** are tones and **plum** is a shade of violet. You can be a fanatical thinker and judgmental of others with tendencies toward inertia. You have a serious approach to problems and offer sound, creative solutions. You project a greater concern for the spiritual or psychological over the physical and material. Wear deep violet to tranquilize the nerves and to stimulate altered states of consciousness and psychic development. Wear mauve to express originality, sophistication and a modern style.

POWER COLOR COMBINATIONS

Violet with Red - You desire a relationship that is erotically stimulating. You project a dynamic and magically charming personality. Wear purple with rose for others to have confidence in you. The vivid and deeper tones express an exotic nature. The warmer purples and soft tones add originality to your appearance. Lilac portrays a delicate and sensitive nature.

Violet with Orange - You need to express your clever ideas in group situations. You project a wild sense of humor and like to to play jokes on others. Wear purple with salmon, coral, or peach to be acknowledged for your artistic talents. Wear lavender or lilac with soft peach or light salmon for religious or spiritual celebrations. This is a popular and fun combination for babies to wear.

Violet with Yellow - You need new and exciting experiences. You desire popularity for your expressive charm and well-liked personality. You have a rich imagination and enjoy fantasizing. Wear violet or purple with golden yellow for creative intellectual stimulation. Wear lavender, orchid, or lilac with pale yellow, when you need to be treated with sensitivity and positive regard. A favorite color combination in infant's wear, for a newborn baby's first arrival from another realm of existence.

Violet with Green - You express your positive traits to make a favorable impression on others, to gain special recognition and considerable influence. You are original and very sensitive to others' reactions to you. You are drawn toward a holistic healing lifestyle. Wear purple with turquoise and rich greens to add flair to mundane tasks and to pursue self-help studies.

Violet with Blue - You desire an idealized love or intimate relationship with empathy, harmony, deep affection and gentleness. You are responsive to esthetics and beauty. Wear purple with aqua, robin's egg and any tints of blue to inspire others' creative imagination or when working in the arts. Wear violet with deep blues to soothe your mind and relax your body.

Violet with Indigo - You have a desire to develop your creative imagination and/or psychic ability and intuition. You project a noble image, sincerity and unique individualism. Wear royal or navy blue with vivid violet and bright purple to express your creative ideas in a group or family situation. Wear periwinkle with lavender or lilac to exercise spiritual judgment and to stimulate your creative imagination to problem-solve for family or groups.

Violet with Brown - You desire earthy, sensuous stimulation and luxurious surroundings. You have a need to change your relationships and ideals. You project a congenial, warm personality while expressing your individuality in a normal way. Wear lavender and beige or any light matching combinations to subtly express your creative self in a calm and comfortable environment.

Violet with Black - You desire sensual fulfillment through a bonding relationship that offers physical and spiritual harmony. You express a hidden need for a magical life and an erotic relationship. Wear magenta with black to enhance love-making. Wear purple with black to project a sense of dignity and power.

Violet with Gray - You need to protect yourself against conflicts, arguments, and overwhelming stressful situations. You desire sensitivity and sympathy from others. You project a delicate personality that requires extra special treatment and sensitivity from others. Wear violet with light gray or lavender with charcoal gray for flamboyant refinement and a touch of individuality.

Violet with White - You project sensitivity, refinement and an exotic flair. You desire to make changes in your life and to improve yourself through metaphysics or spiritual endeavors. You are highly intuitive or psychic and responsive to personal changes. Wear lavender with white to express your spirituality, magenta with white to stimulate the imagination and violet with white to soothe nervous tension.

ZODIAC SPECTRUM

The day and month you were born determines your zodiac sign. Your unique planetary portrait reflects the rainbow in specific nuances of each hue.

Aries: bright purple
Taurus: orchid
Gemini: bright lavender
Cancer: lilac
Leo: vivid violet
Virgo: plum

Libra: mauve
Scorpio: rosy purple
Sagittarius: magenta
Capricorn: dark violet
Aquarius: silvery mauve
Pisces: lavender

RELATIONSHIPS

LOVE AND ROMANCE

The colors you favor and wear project a particular image to others. They can enhance your personality and affect how you relate to others, especially in your personal relationships.

If you have a preference for **violet** you are an intuitive, sensitive, understanding and a somewhat erotic lover. Rituals and personal celebrations fulfill your romantic heart. You are the romantic ideal-ist, in constant search for the perfect partner, who is usually of another time or existence. You prefer a dignified, refined, sensi-tive partner, who appreciates the cultural things of life. All the arts are important to you and you enjoy incorporating them into your relationships. Plays, musicals, art exhibits and charming, eloquent parties match your style of an exciting evening out. Having the most exquisite taste, you lavish your beloved with the very best of everything. Beauty and magical love are your true needs.

Lavender - You need to be more realistic in your approach to love and the expectations placed upon your partner. You tend to fanta-size a lot about your romantic interests. Keep your head out of the clouds, put your feet on the ground and keep your focus on reality; stop floating on clouds.

Magenta - You desire the most sensitive intimacy and magical relationship of all. A fun-loving, free-spirited, and unique relation-ship appeals to your rich imagination.

Purple - Candlelight and roses are the themes of your romantic diary. You must have a charming and refined, if not artistic, part-ner. You have the most unusual preferences for a partner that only make sense to your idealistic thoughts and expectations.

FRIENDSHIP

Violet connects you to a spiritual link with friends. Violet promotes the awareness that you and others are one in spirit and leads to unconditional love. The warm, soft shades exude universal love. In these types of friendships there may not be much in common on the surface; however, there is a pervasive spiritual, deep bond between you. Most people wonder how it is that you are friends. It is not that apparent to others. Possibly you have had a past-life experience together and are now brought together for a spiritual lesson, or to complete a former destiny.

COLOR HARMONY

Violet and Red - Both are analogous. They are the sensation of hot and lukewarm. Rose and lighter red with violet creates a charming appearance. Red with lavender or a light shade of violet are not as appealing to the senses.

Violet and Orange - Both are secondary colors. They contain one color in common-- red, however, the other individual colors comprising orange (yellow) and violet (blue) are also strong colors. For this reason these two colors clash and fight each other for attention and domination. Together they express a wildly free nature.

Violet and Yellow - Yellow and violet are complementary and are opposites on the color wheel. They are the expression of the interplay of warm and lukewarm. Pale yellow with medium to deep violet is most becoming. Bright yellow and lavender or lighter violet is less appealing.

Violet and Green - They are very clashing unless one hue is significantly darker or deeper than the other. Soft and warm tones of lavender are quite pleasant with clear, bright and deep green. This combination is mentally healing.

Violet and Blue - The cool and lukewarm properties of blue and violet are analogous to one another. They create positive effects on the mind, spiritual self and the emotions. They work best as a sedative to relax the mind and body.

Violet and Indigo - Both are analogous to each other and contain the colors red and blue. Indigo has more blue, and violet has more red. Together they are very harmonious in all tones. Both appear to recede, although purple will appear to advance ahead of indigo because of its red influence. Together they express deep contemplation and are very healing to the mind and all its mental functioning.

VEHICLES

The color you choose for a car, boat, bicycle, etc., outwardly reflects your inner needs and personality. Only the color you prefer for a vehicle applies to the information below.

Purple is the most unusual color available for any type of vehicle. Your preference for this rare color marks you as an individual who needs special attention and appreciation for your unique qualities.

Neon Magenta - This new bright showy color stands out the best against the green background of nature. You want your car, etc. to reflect your whimsical nature and creative self. You are flamboyant and a non-comformist and are proud of it. To express yourself with flair is more important than to be like everyone else.

SENSES

SOUND - Violet is the musical note of B. Dreamy and euphoric, this melodic tone leads one to enchantment and on occasion, paradise. It is so heavenly that an altered state of consciousness might be experienced. You do not want to listen to this meditational rhythm while driving or performing physically difficult tasks. Its hypnotic vibrations completely calm and sensitize you by taking you to other worlds of existence. New Age music and some religious or holy songs, like the Gregorian Chants, are of this beautifully mystical and magical hue.

TOUCH - Violet is cooling or warmly mystical. The light tints feel magically soft and the dark hue incredibly ethereal, seemingly from another dimension. It's the visionary spark of creativity.

TASTE - Violet is bitter-tasting. Bitter purple herbs, vegetables and fruits are the best for killing germs, for detoxification of the body and purification of the blood system. The worst tastes help you to lose weight and promote cleansing and mental functioning. Consumed in excess, it can induce nervousness, irritability, insomnia and too much weight loss.

VISUAL - Violet is soothing and calming to the mind, it stimulates the imagination and induces sleep or deep relaxation. The warmer tones with red hues are more vitalizing and charming and evoke keen insight (inner perception), sensitivity and fantasy. Magenta and warm purples are the tones of aesthetic beauty and are best used in creative environments.

SCENT - The fragrances of violet are clove, mint and peppermint.

FORM - Shape: the oval relates to **violet**.
Line: the curved line expresses the feeling nature of violet.

DRAWING EXERCISES

Since ancient civilization through modern times, humankind has utilized symbols to express itself. Symbols are a universal language which conveys specific meanings. One shape can evoke a deep response and express many words.

You have been made aware of how colors relate to shapes. Through the process of creating an oval, which expresses the specific color violet, you can experience the feeling and energy of that color. You can draw or doodle an oval on paper, inscribe it in the sand, or in mid-air. Making an oval will help empower you to achieve the following:

1. to explore your inner guidance and develop intuition;
2. to stimulate your creativity;
3. to develop your individuality and to express your unique self.

MENTAL EXERCISES

IMAGERY

Think violet to exercise good judgment, to make positive choices and to calm the body's nervous system. Think warm magenta to stimulate your imagination and rejuvenate your mind and body.

MEDITATION

Allow the violet ray to flow through the top of your head, all the way down through the bottom of your feet. Breathe in the color violet and direct it in your mind's eye. Feel its energy expand your awareness and intuitive self. Now surround yourself with violet light for Divine guidance and protection.

NEUTRALS, METALLICS
AND IRIDESCENTS

The neutrals, **white** and **black,** are both the presence and absence of color. They are completely opposite in nature and are a striking polarity; light and darkness, creation and destruction, divine essence and material form. The balance of these contrasting forces is expressed in their blending together to become the color **gray**.

WHITE

White is the dazzling color of freshly fallen snow, of fluffy clouds and of the peace dove. Throughout nature, white reflects and accentuates the color around it with its brightness. Symbolic of Divinity and purity, white's positive vibration cleanses the old and brings forth the new. White objects are actually colorless and reflect sunlight and light. It is cool in its effects and void of emotional impact. The attributes of white are innocence, perfection, safety, purity, chastity and romantic idealism. Its opposite impressions are bleakness, coldness, sterility, and lack of emotion. It is the color associated with a new and positive beginning.

ENVIRONMENTAL EFFECTS

SURROUNDINGS

Surround yourself with white to recover from a negative lifestyle or situation, to regain a positive attitude, and to begin a new direction in life. White's stark quality gives the appearance that everything is new and clear. It will help you take the necessary steps toward radical change in your life.

SUNLIGHT

White sunlight contains all the colors of the rainbow. You receive the full benefit of every color in equal amounts simultaneously. This powerful healing life-force is essential for the total health of all living things. Even the smallest amount of light is uplifting to your spirit and revitalizing to your physical body. Moderate exposure to sunlight promotes a happier disposition and healthier skin. Its zestful quality enlivens your day.

PERSONAL EFFECTS

A preference for white may indicate that you need to unclutter your mind and begin a new life, situation or direction. You may be taking steps toward radical change in your life. You are sincere and fair in relationships and may appear somewhat innocent. Your nature is fastidious and you are keenly aware of your environment and everything going on in your community. One of your virtues is modesty.

FASHION

White is the best neutral to wear during the summer months or in tropical places. It repels the heat of the sun and helps you feel cool and comfortable. White is impartial in nature. It is best worn with other colors as an accent that adds flair and revivifies the color it's with. White stimuates cheerful effects with saturated hues. Wearing white as an accent with other colors gives a polished and neat appearance. If you need to impress others with style and grace add white as an accent to your wardrobe. White with a slightly bluish tint is the most romantic color. Symbolic of the moonlight, it is the best color to wear when you are hoping for a marriage proposal.

CAREER-FASHION

Health professions benefit greatly from white's reflective nature. White protects you from absorbing any negative elements and repels the negative emotions around you. As a patient, wearing white helps you realize the possibility of positive change in your health condition and to begin life anew. Used in a wide variety of occupations, white's stark and sterile quality gives the appearance that everything is pure and clean. It is most beneficial for restaurant personnel, cosmetologists, health-care professionals and anywhere a germ-free atmosphere is essential.

THE POWER OF WHITE

White is impartial in nature. White by itself is void of emotions. It reflects light and repels negativity. Wearing white as a dominant color indicates a need to totally control your space and be safe from unpleasant people and situations. Worn with other colors as an accent white adds flair and enhances the dominant color. White stimulates the positive effects of vivid or pure hues. Wearing white as an accent with vibrant or deep colors gives a polished and neat appearance. White further softens the gentle and subtle effects of pastels adding style and grace. White sharply contrasts shades or deep hues, demanding attention from others. Ivory, cream, and bone are tones of white.As an accent with other colors these white variations add sophistication, elegance, and subtle definition.

POWER COLOR COMBINATIONS

White with Red - You like to be powerful and influential behind the scenes. You project a quiet demeanor, while inwardly you have unshaken power. This is a great combination for sportswear for games that require quick action and agility. Wine, burgundy, or deep red with cream, ivory or white are best to express your personal power in a socially acceptable manner.

Wear rose and pink with bluish or pure white to be gently persuasive in acquiring delicate and special treatment from others.

White with Orange - You have a desire to make new friends and to experience new avenues of expression. Your child within is ready for safe play and new group adventure. Wear burnt orange when selectivity and caution is needed when meeting new acquaintances. Wear peach and salmon to be on friendly terms with everyone, especially in social gatherings.

White with Yellow - You have a desire to start a new life with unlimited self-fulfillment and endless joy. You are ready to go the extra mile to make positive changes in your life. Wear bright or neon yellow with white to exude cheerfulness and an optimistic disposition. Wear mustard yellow to make important and serious adjustments and to lead others in a new responsible endeavor.

White with Green - You need family harmony and to keep strong family ties. Wear deep green, jade or emerald green with white for physical balancing and a prosperous outlook. Wear turquoise or teal, when you want to be nurtured by family members or a loved one. Wear this combination to express your beauty and accent your positive features.

White with Blue - You desire to make new benevolent friendships. Wear cobalt and deep blues to form deep family roots and a strong spiritual connection to others of like mind. Wear deep tones of blue to express self-reliance and stable unwavering emotions. Wear aqua or Robin's egg blue to exude beauty and a gracious style.

White with Indigo - You are marked as an altruist and a kindred soul to nearly everyone. You desire a universal connection to all living beings. Wear vivid indigo to celebrate a new spiritual life. Periwinkle and bright indigo convey your psychic connection to others, through your Higher-Self. Wear light tones of indigo for meditation or prayer for Divine guidance.

White with Violet - You desire to lead a new majestic and refined lifestyle. You are compassionate and possess strong intuitive awareness and visionary insight. Wear vivid violet for spiritual inspiration and for a regal or honored position. Wear lavender, vivid purple and magenta for celebrations and artistic pursuits. Wear these combinations to connect with your creative imagination and to express your individualism.

White with Brown - Outwardly you project indifference toward a new situation, while inwardly you are stubborn or have a smug attitude. Wear beige or tan to gracefully secure your position in a new situation. Wear these combinations to express an agreeable nature in impersonal circumstances.

White with Gray - You prefer to hide your boredom and dispassionate nature from others. Wear medium tones to help detach yourself from negative circumstances or excessive emotions. Wear soft silvery tones for elegance and sophistication.

White with Black - You project innocence and purity outwardly while you are powerful and strong underneath. You tend to give others the benefit of doubt and relate to the good in everyone. You have a deep desire to begin a pristine new start in an important endeavor. This combination culturally represents new beginnings for formal occasions, such as a wedding or christening.

RELATIONSHIP

LOVE AND ROMANCE

You are a perfectionist, placing great demands upon your partner as you express your highest ideals. Romantic idealism and modesty in relationships are natural to you. Expecting the best in others and in yourself, you strive for unconditional love in all your important relationships. You maintain an objective viewpoint toward your partner's goals and remain clear and direct in your communication. You need to be more accepting of the flaws in human nature and less restrictive in emotional expression.

FRIENDSHIP

White reflects the other person's feelings. It is best to wear when you want to forgive a friend of misunderstandings and to start the relationship anew. White cleanses the heart of negative emotions and makes room for positive feelings.

COLOR HARMONY

In general, **white** is more appealing to the senses when it's used as an accent color to enhance or brighten other colors, or as the main color and accented with another color. White adds a great contrast to dark or vivid colors. It's most harmonious and elegant with pastels and tints, adding great charm and serenity to the atmosphere.

VEHICLES

The color you choose for a car, boat, bicycle, etc., outwardly reflects your inner needs and personality. Only the color you prefer for a vehicle applies to the information below.

White - If you prefer a white car, you are a perfectionist and may need to feel important. White is the best in warm climates for reflecting heat. If you are meticulous about the appearance of your material possessions and are status conscious, white will be appealing to you. White is best for motor homes, boats and cars.

MENTAL EXERCISES
IMAGERY

Think or contemplate white to forgive someone who has hurt or wronged you. White will help you clear your mind of all negative thoughts or ideas. Think white to start a new page in your life. Allow the change to take place inside of you and start a new begining.

MEDITATION

See yourself surrounded by bright dazzling white lights. Breathe in white light and breathe out white light through every pore of your skin and every part of your body. Imagine yourself in the center of an oval of radiant white light. Feel cleansed; feel free; feel anew!

BLACK

Black is the result of mixing the entire spectrum of the rainbow. In the form of light it is the absence of all colors. It is the void, expressing complete emptiness.

Black things absorb light and all vibrations within the environment. The cultural attributes of black are sophistication and formality. Its positive impressions are wisdom and distinction. Its negative impressions are poverty, sorrow, suffering, pain, and death. It is the color associated with crime, secret organizations and renunciation of life.

ENVIRONMENTAL EFFECTS

SURROUNDINGS

Black as an accent, or in small amounts in your environment adds a touch of simplicity and refinement. An overabundance of it can create a feeling of heaviness and depression.

PERSONAL EFFECTS

Preference for **black** marks you as a very private person, who has poise, dignity, savoir-faire and much discretion. You tend to be worldly-wise and highly sophisticated in your approach to life. On a negative note, this can indicate a delving into the negative side of life, tending toward depression or pessimism. You may take unecessary risks and place yourself in dangerous situations. You sometimes possess a "do or die" attitude. You mind your own business and expect others to do likewise.

FASHION

Black is the worst color to wear in tropical and warm climates where it absorbs heat. However, it is very popular in seasonal climates especially during winter months to help retain heat. Since it absorbs whatever energy is in the atmosphere, you should be very careful in choosing this color to wear.

Black is worn at funerals by the loved ones of the deceased, not only because of its symbolic meaning of death, but also its ability to absorb the sympathy, strength and support offered by others for the mourner.

CAREER - FASHION

Black represents wisdom and mystery, as indicated by the garments of some of the clergy, executives, and the martial arts. The formal tuxedo or black-tie indicates an important, worldly affair. It distinguishes the rich and famous from the common folk. Black is best for formal occasions, meetings, and any situation where protocol and worldly honors or achievements are bestowed upon you. You can then project a sense of importance and poise. Black tones down strong colors and intensifies neon and vibrant colors. It is more harmonious with bright and medium shades than pastels.

THE POWER OF BLACK

Black projects sophistication, mysterious power and strength of one's own views and convictions. Black indicates a refusal to change or adapt to new circumstances. As a dominant color, black weakens the effect of the accent color. Black can project an un-caring, uninterested, and unhappy disposition. Black is best worn as a suit for both men and women in formal situations. The accent color is the tie, shirt or blouse. As an accent color, black will highly contrast bright and vivid hues while dulling tints and light hues. The impact of black on other colors is strong and extreme.

POWER COLOR COMBINATIONS

Black with Red - You have a need to hide pent-up emotions that can explode any time as impassioned or impulsive behavior. You project a ruthless, explosive and antagonistic attitude. Reckless and destructive behavior is wildly expressed, while losing total self-control. Wear black with rose to convey deep sexual passions. Black with pink sends the signal that underneath a bold and strong exterior is a gentle, loving person.

Black with Orange - Outwardly you appear authoritarian and in charge of a situation but underneath you are friendly and gregarious. You hide your sociability behind some kind of real or imagined power. You project a coy personality. Wear black with salmon or coral to project a responsive nature in formal circumstances.

Black with Yellow - You have a need to hide a smug attitude and sexuality behind an intellectual facade. You project your personal power through intellectual conversation. Avoid reckless behavior and unwise decisions to escape problems and stressful situations. Wear **black** with light yellow to project cheerfulness and a sunny disposition in a powerful position. Wear black with deep or golden yellow to focus on matters relating solely to career and business success.

Black with Green - You project normal values while hiding your deep desire for status and prestige. You resent any restrictions and hold to your own opinions stubbornly to prove your independence and will-power. You have a need to be in control of the family and your finances. Wear black with pleasing greens for financial negotiations and when acquiring a loan.

Black with Blue - You have a need to hide your ego behind a secret mask. You desire solitude and to withdraw from others to seek inner peace. You desire total relaxation and recovery from emotional or physical trauma. Wear cobalt blue with black for home rest in a peaceful environment. Wear black with light blue when you are in the power seat and want to project a compromising and considerate disposition.

Black with Indigo - You have a need to retreat from your current situation to tap into your personal power and spiritual guidance. You project an image of a mysterious and secretive person. Wear black with vivid indigo to project sophistication and an assured demeanor in formal settings.

Black with Violet - You refuse to compromise for fear of emotional and intellectual disharmony. You project a mysterious, magical and exotic nature. Wear black with lavender to express your artistic bent and individuality in a formal situation. Wear black with magenta to attract a romantic partner in a formal situation.

Black with Brown - You express embitterment and disgust with life's disappointments. You need to get away to a safe, comfortable, and problem-free place. You are badly in need of a vacation from your overwhelming responsibilities. Wear black with tan or beige in a business or career situation to express cordiality behind your professional demeanor.

Black with Gray - You have a need to isolate yourself from situations and others that will cause depression or fear. You are secretly indecisive and noncommittal. You project a strong desire for hidden power. Wearing black with light gray is most appro-priate for a funeral of a loved one or a formal affair.

Black with White - You project a powerful and strong image, yet are inwardly harmless. You are not a middle of the road person preferring to be judgmentally pure. Wear black with white in the most formal situations to project sophistication and worldliness.

RELATIONSHIPS

LOVE AND ROMANCE

If you prefer **black**, your taste is conventional, favoring formality and romantic escapades. You are intrigued by mysterious inter-ludes. You like a distinguished gentleman or a highly sophisticated lady as a partner. Formal dining, dancing and private weekend getaways entice you, as do all the worldly entrapments of sed-uctive romance. Black silk or lace is your style. A wealthy am-biance, including limousine service, diamonds, and luxury in general, is your idea of a good time or night out on the town. You can be a smooth operator or a "classy sassy," or remain roman-tically unattainable.

COLOR HARMONY

The combination of black and white is most striking and attractive. It expresses formality and taste. As the dominant color, black is very appealing with all colors. It creates a bold and polished appearance when it is the dominant color with bright and vivid hues. Avoid dark colors with black. It is too heavy in appearance and lends itself to a depressing and lifeless effect.

VEHICLES

Black - Your preference for a black vehicle reveals your desire for luxury and material possessions. Culturally, black signifies sophistication and social importance, (note the black limousine). Black is sleek and mysterious in appearance. If you select black for a sports car or motorcycle, you are somewhat risk-taking and fearless in your approach to driving. Black reflects your need for formality, dignity and style.

MENTAL EXERCISES

MEDITATION

Black has no positive use in meditation, because of its negative connotation throughout Western history.

GRAY

Gray is the blend of white and black and contains a mixture of both qualities. It is monotonous and dull in appearance. It represents complete detachment and old age. Its attributes are protective, safe, hard-working and self-controlling. Its negative impressions are boredom, non-committment and tedium. It is the most drab and deadening color for a child to wear.

ENVIRONMENTAL EFFECTS

SURROUNDINGS

Gray is best as an accent color to your surroundings. It is especially tasteful with warm pastel tones and gives a fashionable impression. Too much gray is not only drab, but very boring to look at. However, it is a great color in environments where you need to tackle hard physical or mental work and need to concentrate or focus your attention on important details.

PERSONAL EFFECTS

A preference for gray reveals your need to feel safe, secure and comfortable in a modest and quiet way. You wish to remain moderate in most situations. You make decisions through your reasoning abilities, not your emotions. A hard worker, you demand integrity from others and perform all responsibilities with great care and diligence.

FASHION

Gray is the most neutralizing color to wear. Worn in various shades and tints, gray is most appealing. This is the best color to wear for situations which require you to use the power of your role of authority, not your personality. It is the best color to wear under severe emotionally or physically taxing situations. It can help cool down an over-bearing situation. However, its drab nature can put years on your physical appearance. Wear it sparingly. Gray represents old age.

CAREER-FASHION

Gray hides your true personality. A salesperson wears gray to appear impersonal, fair and unbiased. Wearing variations of gray can help you remain cool and emotionally unaffected by the reactions and opinions of the customer. It's also great for politicians, executives and those in most positions or occupations where one needs to be self-controlled and socially accepted by all types of people. It allows diverse acceptance of *what* you are in the world, not *who* you are. It is the best color for situations where your authority and expertise is more important than your personality.

THE POWER OF GRAY

Gray is the color to hide behind or conceal something. As a dominant color gray allows your true feelings and the meaning of the accent colors to be hidden or concealed. So, if you have a desire not to reveal your real personality, intentions, motives or desires, wear gray as a protective cover-up. Gray is neutralizing, void of personality, impersonal and implies non-involvement. Wear gray in formal or professional settings to express elegance and soft sophistication.

POWER COLOR COMBINATION

Gray with Red - You try to conceal your desire to impress others with your personal achievements through cautious and rational action. Wear gray with burgundy in a formal or business setting when you are inwardly undecided but need an outward appearance of assurance and maturity. Wear gray with pink in the beauty business to project youthfulness with a mature and serious nature. Wear rose with silvery gray when you need to enlist others as benefactors or supporters in your business.

Gray with Orange - You have a need for more fun in a dull or boring situation. Under your impersonal exterior is a child ready to play. You project a vibrant personality in a socially acceptable way. Wear charcoal gray with peach or salmon for important business networking and public lectures. Wear light gray with vibrant orange or light tones of orange in sales, the building trades, communications, and working with the public.

Gray with Yellow - You need protection against arguments in an unavoidable situation. You project impartiality and a no-nonsense attitude with a lively intellectual repartee. Wear all grays with pale yellow for mathematical and studious pursuits, working with computers and success in business management.

Gray with Green - You conceal personal intentions to avoid hostile attack or any opposition which might jeopardize your plans. You project outward indifference or disinterest in relationships, while inside you greatly cherish the love of the family and traditional values. Wear charcoal gray with turquiose or light green in situations that require you to be objective in family or business financial situations.

Gray with Blue - You project a need for peaceful conditions and avoidance of arguments and conflict with others. You hide your willingness to compromise. Wear charcoal gray with Robin's egg blue in professional situations where your subtle charisma wins the admiration of others. Wear light and medium gray with peacock or aqua, in professional or formal settings to convey a caring and understanding nature.

Gray with Indigo - You project a sense of detachment and neutrality toward others. You have a need to let go of past hang-ups and re-establish your important and meaningful relationships.Wear charcoal gray with periwinkle or light indigo in formal situations to express debonair, cheerful qualities. Wear navy or royal blue with light gray in drastic situations that require a sobering affect on the mind and emotions.

Gray with Violet - Your fantasies and eroticism are hidden by a cautious and exploratory disposition. You project objectivity and acceptance toward others, while your real opinions and imagination are held in check. Wear gray with lavender or light purple in situations that require creative changes in your life. Wear light gray with lavender, orchid or lilac in beauty and home decorating sales or public relations.

Gray with Brown - You need protection from physical exhaustion and insecurity. You project low self-esteem. Wear gray with beige or tan only in business or formal settings that require you to be impartial and impersonal in a warm way.

Gray with Black -You project a desire to revolt against injustice and mistreatment. You prefer to be rebellious in a quiet way. Wear gray with black only in business or formal settings where you need to be unemotional, indecisive and to employ business ethics.

Gray with White - You project an impersonal, passive and aloof nature. You have a need to be emotionally decisive and to focus your energy. Wear gray with white in business or formal settings that require objectivity and a hidden personality.

RELATIONSHIPS

LOVE AND ROMANCE

The colors you favor and wear project a particular image to others. They can enhance your personality and affect how you relate to others, especially in your personal relationships.

Gray lovers like being involved with a partner on all levels, except emotionally. If you prefer gray, you may be looking for an exciting relationship with little or no commitment. Avoid an all or nothing attitude. You may be avoiding closeness as much as you might fear, fear itself!

Light Gray - You are concerned about losing control. You withhold feelings and hide to remain in a relationship with little or no commitment.

Medium Gray - You tend to vacillate between personal isolation and a false bravado. You remain middle-of-the-road in most decisions in the relationship, unable to reveal your true feelings. You want the relationship to be free of anxiety, competition and responsibility.

Dark Gray - You may lean towards a selfish nature and not be interested in a serious relationship. You dislike submitting to other's personal powers. You may be irritable or involved in a distressing situation, which severely inhibits your capacity to be intimate.

COLOR HARMONY

Gray has a greater appeal to the senses when you accent it with a warm color, such as pale yellow: intellectual; light orange: diplomatic and convivial social grace; red: attention; and mauve or pastel lavender: warm and modern impression.

VEHICLES

The color you choose for a car, boat, bicycle, etc., outwardly reflects your inner needs and personality. Only the color you prefer for a vehicle applies to the information below.

Gray - Gray and silver tones are mechanical colors and are most appropriate for a machine like a car. However, they are not practical colors for boats and aircraft since they are difficult to distinguish in their environment, and the silver tones create a glare from the sun.

If you prefer the **gray** or silver shades for a car, you may feel impersonal towards it and not pay proper attention to its required maintenance and physical appearance. Your attitude of indifference can be harmful to the vehicle in the long run. Selecting silver tones reflects that you are practical and moderate in your habits. You like to have a routine existence, where everything has its own proper place and function. You are a realist in your outlook and exhibit self-control in most circumstance.

MENTAL EXERCISES

IMAGERY

Gray has a sobering effect upon your mind. Think gray to hold back angry words and emotional outbursts. Gray is the great stablilizer for mental and emotional excessiveness.

MEDITATION

Visualize a smoky gray cloud whenever you need to control your excessive nature. Allow the cloud to float over your head to control obsessive thoughts; over your mouth to control bitter or negative words; over your chest to prevent anxiety; over your heart to neutralize hate; and over your stomach to avoid over-indulgences. Meditate on gray for moderation in all excessive things.

BROWN

Brown is comprised of two opposites, blue and orange. Rust brown and rich, warm brown contain a greater amount of orange. Another brown hue which has more of a gray cast, like taupe, is made by combining yellow and violet. The brick or red tones are made of the opposites red and green. Consequently, any two pairs of opposites on the color spectrum, when mixed together, create brown. Brown is a color completely in its own isolated category.

ENVIRONMENTAL EFFECTS

SURROUNDINGS

Brown in the environment creates a secure and earthy effect. It's warm, neutral vibrations give the feeling of safety. Since brown is associated with the ground and the outdoors, it is very natural as an outside color of a home. Various light tones of brown, such as, beige, tan and mushroom are popular accent colors for carpeting to give a neutral and natural effect. Most any colors match well with soft and medium tones of brown and add a soft, warm touch.

PERSONAL EFFECTS

If brown is one of your favorite colors, you tend to be practical, earthy, somewhat stubborn, consistent, and responsible. If you prefer the orange tones, you enjoy sensuous surroundings and a comfortable life. You can either be a homebody or entirely rootless, making everywhere and anywhere your home. The darker the brown, the more critical you are towards others. You demand respect from others, but frankly care less what they really think of you. You are merciless in condemning others who are more free and breezy in their lifestyles than you. The lighter tones of brown make you a little more mellow in your attitude toward others and life in general.

FASHION

Since it has an earthy and natural quality, warm brown, tans, beiges, and golden brown are popular in clothing. Almost any personality type will end up wearing one or more of these colors regularly because of their availablility in the clothing industry. If you are down-to-earth, conservative and somewhat complacent, you will like the medium tones. The more sophisticated in taste prefer the soft and beige tones. Although brown is a safe and comfortable color to wear, the darker tones and deep shades project a melancholy effect. You will not stand out in a crowd or even be noticed when you are wearing dark brown.

Chocolate brown is a rich and luscious brown that tantalizes the senses and is warmly sophisticated.

CAREER - FASHION

Occupations that are service-oriented tend to use **brown** for uniforms. Brown gives the appearance that you are responsible, reliable, and ready to assist others. Many fast-food clerks and delivery services use this color. Because of its orange mixture, brown is a friendly neutral. It projects warmth and impartiality.

POWER OF BROWN

Brown projects a sense of security, stability, reliability and physical comfort. Brown is the service-oriented or business person's color and represents convention and tradition.

Tan is a tint and **beige** a pastel of brown. You project a warm personality and are people oriented. You prefer moderation and safety in everything you do and maintain the status quo. Wear tan or beige with cool colors; green and blue for a calm, subtle and comfortable feeling. Wear light brown with the warm hues; orange, red and yellow to evoke their dramatic and dynamic qualities in a more subtle and socially acceptable manner.

Taupe is a tone and **coffee** and **chocolate brown** are shades of brown.You desire sensual and worldly comforts. Avoid emotional obsession about your needs. You avoid commitment through isolation and can be stubborn and standoffish. Wear the darker forms of brown with blues and greens in service-oriented businesses to compromise and please the customer. Wear reds, oranges, and yellows with the darker browns to express a cordial and demonstrative personality in a respectable manner.

POWER COLOR COMBINATIONS

Brown with Red - You have an intense hidden urge to express your sensuality. You project an acceptable and safe passionate nature. Wear tan or beige with light red or rose pink to express your passion for love and life with moderation.

Brown with Orange - You have a need for exciting and secure relationships. You project a stable and friendly disposition to everyone. Wear tan or beige with peach or light orange for warm diplomacy and simple sophistication.

Brown with Yellow - You desire freedom from mental worries and want a secure lifestyle. You project a carefree personality with a taste for sensuous and pleasurable comforts. Wear all types of brown with yellow in service and communication fields. Wear tan or beige with yellow to project an intellectually friendly nature.

Brown with Green - You project self-control under dire circumstances. You need a situation that is safe and secure. Wear chocolate brown with turquoise, when caring for the elderly or physically challenged. Wear emerald green with all types of brown for grounding your energies and healing your body. Wear tan with dark or deep green for financial business dealings and for outdoor family activity.

Brown with Blue - You desire conflict free home with all the material comforts. You need relaxation and a vacation from exhaustion or distress. You project warmth with a willingness to compromise with others for greater harmony. Wear tan with light blues or robin's egg for a peaceful companionship. Wear warm brown with aqua in professions that provide loving care and considerate treatment for the elderly and physically challenged.

Brown with Indigo - You have a deep need to maintain traditional family values for your own stability and inner security. You are unwavering in your views and beliefs. Wear beige or tan with navy or royal blue for a conservative look and business negotiations.

Brown with Violet - You desire a life of overindulgence, luxury and sensuous comforts. You project an obsessive nature in creating your wildest dreams and fantasies. Wear tan or beige with lavender or light purple to project a warm and friendly personality while expressing your creative urges in moderation.

Brown with Gray - You project low self-esteem and need rest and relaxation from an overwhelming lifestyle. You strive to protect yourself from destructive or unpleasant situations. Dark brown with charcoal gray projects a selfish and unyielding disposition. Wear tan or beige with charcoal gray to appear warmly impartial in a professional or formal setting.

Brown with Black - You project an unyielding nature in pursuit to achieve unrealistic goals. You have a desire to forget bitter disappointments and want to hide in a safe and problem free world. Wear tan or beige with black to project a stable and sound personality in a profession, where you are an authority figure or in management.

Brown with White - You desire security and the comforts of the good life with a fresh new start. You project a stubborn or smug attitude, while inwardly you are wavering. Wear tan or beige with white for elegance and style in pursuit of a business or profess- ional relationship. Wear medium and dark browns with bone or ivory in formal situations for a rich and luxurious appearance.

RELATIONSHIP

LOVE AND ROMANCE

As a **brown** lover you prefer a partner from the same background or social class. Once you fall in love, you plant your feet solidly on the ground and remain committed to your sweetheart, whether or not you marry. You can also remain hooked on someone even after he or she marries someone else. Despite your many short- comings, you uphold honesty and frankness in your manners. You lack pretense, and are natural in your relationships. You are a believer in the family traditions and are old-fashioned in courtship.

Reddish Brown - implies a little bit of lustfulness in your earthy approach to love. You may appear reserved on the surface, but underneath you are quite sensuous. You may prefer someone almost identical to you.

Medium Brown - indicates that you may depend upon your mate too much, but may be critical and judgmental of every move your partner makes. Your mate will always need your approval. You prefer someone who will look up to you and honor your practical viewpoint.

Dark Brown - indicates a more irritable disposition. You need to lighten up and be less serious about the faults of others and more aware of your own short-comings. Avoid becoming over-demand- ing and super-critical of your loved one. You prefer a partner who is more passive in nature and allows you to totally dominate the relationship.

COLOR HARMONY

Brown is a warm accent color and appears best with warm hues, either light or of the same shade. Combined with variations of orange, yellow, green and blue, brown is very warming in its effect. Beige with other warm pastels is very appealing and creates a soft, earthy look. Also, light tones of brown are appealing with all colors and have a softening effect on them.

VEHICLES

The color you choose for a car, boat, bicycle, etc., outwardly reflects your inner needs and personality. Only the color you prefer for a vehicle applies to the information below.

Brown - Brown, beige, and tan are the warm neutrals abundant in nature. If you prefer brown for a vehicle, you are expressing your need for comfort and security. Selecting an orange brown or rust vehicle implies that you prefer genuine materials for the interior, such as leather, velour, and wood. You may treat your vehicle as if it were your home. If you choose variations of tan or beige, you are less sensuous and more stylish in expression. In general, a preference for brown tones reveals that your honest manner and your direct and simple communication brings you success. Your car, etc., may be representative of your hard-earned success.

MENTAL EXERCISES

IMAGERY

Think brown to feel safe and secure and to center yourself from an emotionally charged day. It can ground you from a frantic and confusing pace.

MEDITATION

Visualize yourself hugging a tree. Become one with the tree and allow your feet to become the roots of the tree. Feel grounded, secure, and at one with nature and all life!

METALLICS

Rather than absorb light like black, or reflect light like white, iridescent and **metallic** colors scatter light. This is why they appear dazzling and sparkling to the eyes. The interplay of color and the dynamic color changes represent the passage of life through the course of time; the dance of life. As you spiral into the space-age life style, the metallic and silvery gray tones will become more popular and prominent in clothing and commercial accessories. Simplicity in design and form will be more marketable and have more mass appeal. As life becomes more complex, you will tend to strive for simplicity. This space-age trend which has already begun, will be even more dramatic in the year 2001. With advanced technology and computers integrated into your daily routine, color choices will become more cosmic and iridescent in all areas.

METALLIC COLOR EFFECTS

These are more detached and impersonal in their effect. They evoke excitement, enticement and attraction. They may sparkle your inner child with their awe and beauty. Overuse of this color type can become gaudy and overbearing.

WARM METALS

Gold - warming in its effects, its colors range from white, glowing yellow and slight pink to soft green. Besides being highly attractive and ornamental to the wearer, it has a strengthening influence upon the body.

Copper - when polished, is warm in nature. It has been known to protect the physical body and have healing benefits for arthritis. It can stimulate passion and intensity in your life. In its aging state, it turns green, adding a coolness to its warmth. Its effects are outstanding for healing and balancing the body.

COOL METALS

Silver - cool in nature and impersonal in appearance, silver has a stabilizing effect on the body and the emotions. In its tarnished state it becomes more neutralized and less effective.

Gray Metals - pewter, nickel, tin and all dull or silvery metals are neutral in appearance. They need bright or deep colors to add life to their presence. Their boring, dull mechanical qualities make them less popular than silver and the warm metals.

PERSONAL EFFECTS

If you immensely enjoy and wear glitter, sequins, and **metallic** colors, you are a true futurist, ready to explore space and progress into a more advanced society. You are probably living in the future through the way you view life in general and how you interact with others. If you favor the warm metals, especially gold, your taste is refined, you prefer the exquisite things in life. However, if you prefer silver over gold, you also enjoy the same but with less flash and more imagination. The dull gray metallics are more appealing to the conservative and less sensitive types.

VEHICLES

Metallic - Metallic colors are the most appropriate and attractive for cars, and seem to be more expensive. The popularity of this color range is due to the fact that they make a mechanical object more appealing and seemingly from another dimension. It gives a little more life to its non-human, cold and impersonal appear-ance. Its effects are more warming than gray, cold steel.

The splendor or sparkling quality of gold is not as in demand as the color silver in cars. This is due to the glare on the eyes, making it quite difficult to even look at. However, the gold Rolls Royce is still a status symbol, representing the finest, most exquisite of taste in cars.

MENTAL EXERCISES

MEDITATION

Visualize yourself covered in sparkling golden sequins. Walk directly into the path of the dazzling warm rays of the sun and allow the rays of sunlight to flash off you in all directions. Become like a mirror reflecting the powerful glow of the sun and shine your rays of love and joy as beauty to everyone. Become exhilarated by the *sunsation*.

IRIDESCENTS

There is very little known about the **iridescent** colors. In nature these enchanting hues exist in abundance in sea life, insects and birds. The beauty of an opal, a peacock feather, or a tropical fish has fascinated and charmed our universal inner appreciation. Seemingly from another world, these brilliant colors flirt with the child within and inner dimension of your entire being. They express the ethereal side of existence, the dream state, the altered state of consciousness, speaking to your spiritual interior. This brilliant and radiant myriad of changing hues appear somewhat surreal.

PERSONAL EFFECTS

If you favor the **iridescent** colors, you are definitely interested in other worlds of existence and enjoy using and exploring your imagination. You appreciate the magical and mystical aspects of life and are not afraid to enter a new dimension of life or altered state. Possibly your soul is seeking greater expression and higher attainment in this lifetime. You would like to go back in time and merge with the powers of the universe that brought you to earth. Meditation and understanding metaphysical realities are natural to you. Possibly you are developing or becoming more aware of your psychic abilities and spiritual purpose.

FASHION

The shiny multi-colored hues of iridescents flirt with the eyes and stimulate your imagination. Wearing any color assortment conveys your desire for a magical and enchanting experience.

BEAUTY- PALETTE - Colors enhance your total appearance, especially when they are harmonious with the shade of your hair.

The metallics and the iridescent colors can be worn by all palettes. They are universal in their appearance. However, the colors of the iridescent hues are the same as the color key in each of the individual color chapters.

Pale Blonde: white, black, gold, and copper
Dark Blonde: bone, jet black, gold, and copper
Red and Auburn: white, mars black and copper
Light Brunette: cream, grays, light and dark brown and silver
Dark Brunette and Black:off-white, charcoal gray, jet black, silver
Gray and White: rich black tones and silver

ZODIAC SPECTRUM

The day and month you were born determines your zodiac sign. Your unique planetary portrait reflects the rainbow in specific nuances of each hue.

Aries: earth brown
Taurus: copper
Gemini: multi-iridescent
Cancer: pearl white
Leo: gold
Virgo: pewter

Libra: beige
Scorpio: mars black
Sagittarius: silvery blue
Capricorn: charcoal gray
Aquarius: bright iridescents
Pisces: opalescent

MEDITATION

Visualize yourself sitting in a cosmic rain shower. Observe the falling rain as it sprinkles on your face. Concentrate on one raindrop at a time. See the myriad glistening colors of the rainbow running up and down the raindrop. Become the splendid hues as they change colors to the rhythm of your breathing. Experience what it feels like to become each color; see it and feel it. Become red, orange, yellow, green, blue, indigo and violet in iridescent hues. Now feel what it's like to become a rainbow and express the colorful aspects of your entire being. Breathe a rainbow into your heart and have a rainbow day!

COLOR MANDALA MEDITATIONS

Draw and color your own mandala. Experience your own personal meditation through this enjoyable process. Use your imagination and let your inner-self flow.

VISUAL COLOR MEDITATION

A visual meditation is the practice of focusing or concentrating for a certain period of time, on a specific form to achieve a beneficial purpose.

The color mandalas at the beginning of each chapter and on the back cover of this book were especially created for the meaning of each individual color of the spectrum. In order to get the full impact of each color, take a sheet of white paper and cut a circle a little larger than each mandala on the back cover of this book. Then place the open circle over the color mandala you wish to focus on.

Each exercise is designed to allow the images and color to stimulate your creative-self and to acknowledge each color as an important expression of your life.

RED MANDALA MEDITATION

Allow your eyes to become your visionary kaleidoscope. Focus at the center on the rose, then move clockwise to the outer edge, observing every detail. Absorb the vibrant color red inside of you. Now contemplate each word and its meaning: *love, vitality, strength, energy, achievement* and *courage*.

Concentrate on the entire red mandala for a moment. Feel the vibrant energy of love, as a budding rose in your heart; allow the magical unicorns to stimulate your imagination and the spirit of soaring doves to fill you with courage and vitality. Focus on this mandala to become self-confident, physically motivated, creatively stimulated and to achieve your heart's desire.

ORANGE MANDALA MEDITATION

Focus your eyes for a moment at the center on the hands holding the earth. Allow your eyes to look clockwise at the flowers, then the setting sun. Continue moving your eyes in a circular fashion, observing every detail. Let your eyes absorb the vivid color orange inside of you. Now contemplate on each word and its meaning: *friendship, sincerity, mystery, enthusiasm, nature, freedom* and *kindness*.

Concentrate on the entire **orange** mandala for a moment. Walk into the luminous setting sun and become aware of your connection with nature and all living things. Feel the warmth of the sun and be thankful for all the abundance in your life. Focus on this mandala to develop diplomacy and congeniality and to stimulate your appetite.

YELLOW MANDALA MEDITATION

Focus your eyes at the center of the sun, moon and stars. Allow your eyes to look clockwise at the unicorns and rising sun. Continue to move your eyes in a very circular fashion until you reach the edge of the circle. As you observe every detail, let your eyes absorb the brightest color yellow, inside of you. Now contemplate each word and its meaning: *happiness, fulfillment, radiance, joy* and *enlightenment.*

Concentrate on the entire yellow mandala for a few moments. Feel the glow of the sun and stars radiate throughout your entire body and around you. Focus on this mandala to become uplifted, to stimulate mental concentration and to open up your heart to the celebration of life.

GREEN MANDALA MEDITATION

Center your eyes at the geometric design in the middle. Allow your eyes to move clockwise around this image focusing on the world and continue gazing in an outward circular fashion, observing every detail. Let your eyes absorb the soothing color green inside of you. When you reach the edge of the circle, contemplate each word and its meaning: *life, health, prosperity, faith, will-power,* and *growth.*

Concentrate on the entire green mandala for a moment. The greening power will promote balance, abundance and health in mind, body and spirit. Feel the soothing vibration of green to exercise your will-power to become whatever you believe yourself to be and regenerate yourself.

BLUE MANDALA MEDITATION

Focus at the center on the loving peace dove and the rainbow. Study every detail of the castle above it and the waves of the ocean below it. Move your eyes clockwise, gazing at each flower, then the clouds and lovebirds, etc., until you reach the outer edge. Let your eyes absorb the calming color of blue deep inside of you.

Ponder each word and its meaning: *peace, harmony, beauty, prayer, calm* and *unity*.

Concentrate on the entire **blue** mandala for a moment. Enter the castle inside the floral wreath and contemplate the beauty of its treasures. The calming vibrations of blue will provide peace and harmony in your life. Feel blue's gentle energy calm your emotions, soothe your mind and relax your body.

INDIGO MANDALA MEDITATION

Focus on the iris in the center. Move your eyes clockwise, studying the detail of the ring of flowers and stars around it. Allow your eyes to study the outer images in a likewise direction until you've reached the outer edge. Let your eyes absorb the deep relaxing color of indigo inside of you. Contemplate each word and its meaning: *ideal love, devotion, trust, tranquillity, contentment* and *loyalty*.

Concentrate on the entire indigo mandala for a moment. Enter the caressed heart and feel your feminine and masculine energies balanced. Feel the unconditional love from the entire universe caress your heart and spirit. Allow the deep relaxing vibrations of indigo to direct your heart and mind to know the truth and receive Divine guidance and trust.

VIOLET MANDALA MEDITATION

Focus on the violet lotus blossom at the center. Sense its wonder and beauty within you. Allow your eyes to study every detail of the unicorns surrounding the lotus. Gradually move your eyes from the center to the outside of you. Contemplate each word and its meaning: *creativity, spirituality, intuition, inspiration* and *sensitivity*.

Concentrate on the entire mandala for a moment. See the violet lotus blossom in your mind's eye. Become aware of the gentle, silent knowledge within you. Be still and listen to the intuitive language within. Open yourself up and feel the vibrations of violet spark your creative imagination and spiritual sensitivity.

NEUTRAL MANDALA MEDITATION

Focus at the center of the mandala and allow your eyes to naturally move clockwise from this point outward to every symbol. First the zodiac symbols, then the planetary symbols, now the world philosophy symbols at each point of the star. Now just focus on the star and all the images within it. Concentrate on this shape in the middle of the mandala to feel centered.

Focus on the top of the star on the Egyptian symbol for women representing all the elements. Allow your eyes to move in a clockwise manner and observe each individual small circle around the star. Concentrate on the elements of fire (ignis), water (aqua), earth (terra) and air (airis), as you explore all the symbols of the sun and moon. Concentrate on this central portion of the mandala, including the star, to feel your connection with the earth and all living things.

Focus on the outer ring of the mandala moving clockwise from the top. Notice the soft forms of a man and woman sharing a flower. Observe all the symbols and the rhythm of the interweaving flowers. Concentrate on the outer ring to become balanced with your male and female aspects and to develop spiritual awareness.

Focus on the entire mandala. Feel the oneness of all creation and the universe. Become aware of the universal love within all living things. You are like a centrifugal force spinning in time and space, interlocked in unity with all living things as One. You are the universe and the universe is you. Feel the unity of this Oneness.

MAGENTA MANDALA MEDITATION

(COLOR YOUR DREAMS)

Focus for a moment on the entire magenta mandala. Enter the illuminated path of the mystical garden of delights and explore with the child within. Observe all the magical characters of this enchanting fantasy land. Allow the color magenta to stimulate your creative imagination. Feel the joy and exuberance of youthfulness. Become rejuvenated! Now contemplate each word and its meaning: *fun, gayety, fascination, universal love, rejuvenation*, and *charm*.

Concentrate on the magenta mandala to expand your imagination, to experience and recall vivid dreams, to creatively solve problems, to send someone love and to rejuvenate your mind and body.

COLOR YOUR DREAMS

Your **dreams** are as individualized as your finger prints. You are the artist, the true animator of your personal creations, the dream. Therefore, only you can clearly interpret your dreams.

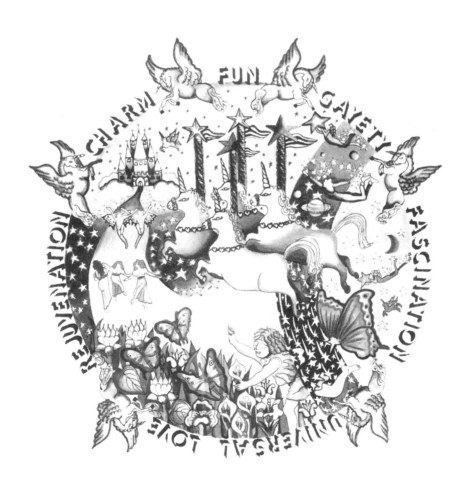

DREAMS: YOUR COSMIC RAINBOW

How important are your dreams?

Consider the fact that you may spend from 5 - 8 hours per night in the sleep state. This awesome amount of time is nearly 25% of your day, and approximates 90 - 120 days of sleep time per year! During your nightly sleep, an estimated 90 minutes is experienced in the dreaming process! Nearly 535 hours per year, or approximately 22 days per year, are experienced in the dream state.

The dream process is still not totally understood by today's most advanced scientists. Yet throughout primitive and civilized stages of humankind, dreams have held great importance to the understanding and knowledge of tribes, families, communities and individual lives. Their significance has played a vital role in political decision-making for world leaders, influencing their personal lives, as well as shaping history.

What is this mysterious phenomenon, the dream?

Dreams are actually the result of sensations or signals from your subconscious mind! They occur to help you face and solve your overwhelming or rejected problems or worries. They also aid in releasing pent-up emotions that lie under the surface and remain unrecognized by your conscious mind while you're awake.

When you are asleep, your mind is really free to wander and explore other dimensions of consciousness or levels of existence that may not be entirely accepted by the rational mind.

A fantasy is a controlled dream of your vivid imagination, your conscious thoughts. The dream in the sleep state is controlled by your subconscious, which is your universal connection to all humankind. While you are awake, your conscious mind is primarily operating in conjunction with your unconscious thoughts, which influence your actions, emotions or experiences. When you are asleep, your subconscious and collective unconscious are in charge. Many layers of your conscious and unconscious world are revealed to you in your dreams. It's almost as if you've been walking around all day in a fog or with a veil over your face. The dream peels away the layers of disguises and shows glimpses of truth and clarity of a particular situation or concern.

The American psychic and healer, Edgar Cayce, once stated that everything that has happened to you is dreamt first! Isn't that an astonishing thought?

Just think how you would be able to understand and handle yourself and all of life's challenges, through the greater awareness of your dreams. It is of tremendous importance that you become aware of what your dreams are really telling you.

It is a scientific fact that most dreams are remembered in black, white, and gray tones. Very infrequently dreams are recalled in full or partial color. In fact, the majority of dreams are not remembered upon awakening! Even if you can't remember ever dreaming, in reality you have actually dreamed.

DREAMS

Regular Dreams: Food or Chemical Stimulated

Your normal, surreal or nonsensical dreams seem to appear in black, white, and gray tones. Usually they are illogical and don't have a clear purpose. Sometimes your dreams may be enhanced by an active digestive system working on a pizza or other food or substances that are consumed prior to bedtime. These comprise the majority of your dreams. However, if this color type of dream is intensely vivid in experience, it will indicate a physical problem concerning your health or objects in your life.

Partial or Spot Color Dreams: Past Experiences

As you have probably experienced, dreams may deal with a past experience or health problem that is being ignored by you, the dreamer. These dreams are usually in color, but the color is washed out to such a degree that you don't even remember dreaming in full color. Other dreams of this nature will have a particular color standing out or be represented by a colorful symbol. This dream is telling you to pay close attention to a physical problem or an unresolved situation. The presentation of this dream may not appear logical. What will emphatically stand out is a symbolic color or specific vivid colors.

Futuristic or Psychic Dreams

Dreams can serve as warnings to future events or illnesses. These types of dreams are known as psychic dreams, which clearly depict the future, but most of the time are highly misunderstood or misinterpreted. Psychic dreams are as real and vivid as if you were awake. Sometimes you may have this type of dream and confuse it with a past experience, thinking that it might have already happened in the real world. These dreams are so real that the colors are exceptionally intense and the feelings deeply felt. You literally live this dream while asleep.

Upon awakening, you may be shocked to find out that you were actually dreaming and sometimes feel relieved that it wasn't a real life situation. But the feelings from this dream may linger in your mind and even sometimes affect you emotionally from a few minutes to several days, occasionally months, and even off and on for several years, until that dream actually manifests in a real life situation. Psychic dreams are vibrations from a past or future time frame which cannot always be easily perceived in the awakened state. What will and is happening in the physical dimension of time has already been perceived in the spiritual, ethereal plane of existence.

COLOR AS IT RELATES TO DREAMS

Color is an important element in your dreams. Its special effects and its importance may be felt strongly, even if not remembered while awake.

Color experienced in the dream state is the vibration of an inner-dimensional sensation. Thoughts emit energy, energy creates vibrations, vibrations are transmitted into your consciousness in the form of wavelengths, which have a specific color. When you think of a person or situation with emotion, or just feel with your consciousness an intense purpose, your entire body responds to that vibration or light-wave which you've created. Your thoughts become reality and you become your thoughts. Therefore, the thoughts you generate in the awakened state affect the thought patterns of the dream-state. Consequently, it is most important to keep a positive attitude and calm disposition during the day to create pleasant and harmonious dreams at night.

The colorful vibrations you create with your daily thoughts penetrate every cell of your body, are magnetized and radiate heat in the form of light throughout your entire being. This light is invisible to the naked eye, but can be perceived or felt through your psychic sense. The light emanating from the outside of the body is commonly referred to as the aura or auric field. All living things including animals and plant life emit auras. Through a conscious effort, your mind can alter the energy or auric field of your body. It is vital to your well-being to keep your thinking focused on creative and positive thought forms to remain balanced and healthful.

Think for a moment on a very pleasant experience from your recent past. Now focus your mind like a clear video screen in full color on every detail of the given situation. Feel the joy and pleasant sensation of that specific occasion. Become aware of your heart rate, your breathing, your nervous system. Do you notice the harmonious calming of your entire body?

The soothing positive vibrations are healing to your mind, body, and emotions. If these sensations affect you in the conscious state, can you imagine how they would affect you during the sleep-state.

INTERPRETING THE RAINBOW OF YOUR DREAMS

There is no one way or proven system of dream interpretation known to be accurate. However, through the understanding of *color* in the dream process, you can gain greater understanding and insight into your dream messages. With this in mind, the universal color key was constructed to be applied creatively and individually by you. It must serve only as a guide to assist you in examining and exploring the simple meaning of your daily life, as you create the colors in your dream life.

The *colors* of your dream world may take on various meanings, according to your life situation and personality. Explore the rainbow of your dreams and use color as it fits you individually. You are the animator of your dream world, and only you have the key to unlock its colorful mysteries.

RAINBOW DREAM SPECTRUM

Note the color or colors that dominate your dream or frequently appear in sequential dreams. Use the color interpretation as it applies to your dream and your current life situations.

Red - represents the *present* and indicates that you must deal with an immediate situation or urgent news, timely action or the physical body. You need to focus on one of the following: your physical condition, your body's functioning processes and vitality and your personal means for survival. Current situations of importance need to be reviewed. Your goal is to become more actively involved with life. Feel life's force pulsating through you!

Orange - indicates your ambitions will be achieved through social contacts. Reach out to friends and family. Involve others with your ideas. You need to accept responsibility for your recent decisions and new ideas. Focus your attention on your innate connection to nature, your true self, the family, community and the universe at large. Involve yourself joyously with others. Watch your eating habits, which may affect your digestive system. Involve yourself with others and maintain a friendly disposition. Your goal is to develop more positive relationships. Make new friends!

Yellow - represents the *future*. Think through a situation and review your future projects. The decision made affects your future for better or worse. You need to focus on your ability to direct your future, and to empower yourself with positive energy. It is time to look forward with foresight to reach your goal or higher aspirations. Remain positive about your health. Your goal is to become positive about your life direction. Be happy and progress successfully into the future!

Green - indicates the renewal of a situation, or regeneration of your physical health. Proceed with deliberation, be commanding and flexible in all communications. You need to become aware that refreshing new vibrations are here. It's a time of personal growth. Focus on the renewal of your spirit and feel the regeneration of the entire mind, body, and spirit.Your goal is to heal yourself!

Blue - represents the *past*. It can indicate a need for introspection or reflection, or a time for spiritual awakening. You need to concentrate on your emotions, your inner security, and personal expression. Open yourself to all channels of communication. You need emotional support and understanding from others and physical relaxation.Your goal is to be at peace with yourself and others.

Indigo - indicates a need for sensitive intimacy, or a greater commitment to a cause or organization. You need to remain loyal to a friendship and express deep affection. Consult your inner wisdom, your intuition and trust yourself and others in an important situation. Your goal is to be true to yourself and loved ones!

Violet - indicates attunement to higher forces and spiritual surrender. Spiritual guidance is now uplifting your higher self. You need to merge with the Divine source and establish Divine trust. Following your inner guidance, the quiet voice within, proceed with decisions and actions. Your goal is to develop spiritual love for others. Become one with the universe.

COLOR INTENSITY

Dark Colors - If the color is a darkened tone, then the lesson to be learned or the situation at hand is old news or a perpetual problem. The darker the color the more critical and chronic is the situation or need. You will have to face the situation with patience, understanding and endurance. You need to develop a more positive attitude toward others involved. Remain calm and composed while facing the situation.

Light Colors - The pastel and lighter tones imply that your feelings or the circumstances involved are of minor importance. You may be acknowledging these aspects and need to free yourself from them completely or work a little longer on improving them. The lighter hue indicates you are spiritually encountering a change that will be healthier and more harmonious to your true nature.

Bright or Vivid Colors - The vivid, bright colors are speaking to you loudly. These colorful dreams have great impact on your psyche and emotional self. Their imprint and influence in your life may last a long time, making you feel out of touch or a little off-centered. It is important to face your intense emotions and deal with their messages *now*! Since the vivid surrealistic quality is imaged almost like a video screen, it might be a psychic dream, preparing you for an important event or change. Pay close attention to these colors and images. You don't want to forget to record your *colored* dreams. You may need that information in the future.

In summary, the colors appearing in your dreams reveal much about yourself and need to be recognized as important. The darker the colors, the older the problem. You need to get in touch with outworn behaviors or habits that no longer benefit your current situation.

The lighter or pastel tones are relating to unfinished affairs that you've been working on for some time and are just near completion. It is a time when victory is at hand, either within your own self or with a personal situation.

The bright or vivid colors are speaking to you for immediate attention or acknowledgment of your emotions, personal development, or current future situations. Remember, if your entire dream is remembered in total color and crystal clear in detail, as opposed to partial color, it is a psychic message.

RAINBOW DREAM JOURNAL

In order to be able to interpret your dreams accurately, you must keep a dream diary or a cassette recording of them. Every time you awake from your sleep you should record on paper or dictate onto tape what you remember from your dreams. Since all dreams are not remembered consciously, it seems imperative that the ones that are recalled when you awake or at unexpected times during the day are most important to interpret.

When composing your rainbow diary or tape, it helps to simplify matters if you have an easy system to follow.

This will not only serve to help you clarify your dreams, but will also motivate you to remember them more clearly.

Whenever you are made aware of colors or a special color in your dream, your inner voice is trying desperately to communicate with you. It is essential to recall the symbol, the intensity of the colors, and more importantly, how you react to the dream upon awakening. Note the purity of the color and what color dominates, etc.

Answer the specific questions immediately at the moment you recall the dream. This simple dream interpretation process is designed for you to get to the very core of your dreams.

RAINBOW DREAM JOURNAL

Brief dream description:
Immediate dream response or reaction:
1. Who is involved or what do they represent?
2. What is happening in your life that relates to this dream?
3. Your feelings?
4. Where is this occurring?
5. When will you commit yourself to change the situation or yourself?
6. Why is this happening?
7. Why do you feel this way?
8. How can you change or alter the situation to create harmony in your life?

Now check the color interpretation section for further insights. Note over a period of time (days, weeks, months) any dream paterns, repetitions, or changes.

PROGRAMMING YOUR DREAMS

Your dreams can give you the answers to many issues in your life. When programming your dreams it's important that you are clear and concise when questioning what exactly you need to know.

PROGRAMMING PROCESS

The following exercise is recommended to do at least 3 - 7 nights consecutively. Several minutes before retiring take several deep breaths, relax, and clear your mind from all emotions and negative thinking. Write down your question to be answered as concisely as possible. Keep it simple and basic. Now fully concentrate on your question and ask your dream mind to reveal the answer through your dream.

You might even think on the specific color that pertains to the situation. Example: If your question is about a love relationship, concentrate on rose pink; a job - red; finances - green; decision-making - yellow. Check the rainbow dream spectrum, as well as the color sections, to help you determine the specific color for your special request.

May your dreams fulfill the rainbow in your heart!

YOUR AURA

The life force around the you is called the aura. The aura is a partially visible electromagnetic force field emitted from your physical and spirit body and that of an animal or plant.Saints or holy people have been depicted with a halo or color emanation radiating from their heads and bodies. The aura is an ethereal radiation that projects the vibrations from your soul that indicates your mental, physical, spiritual state and expresses your unique personality. Most auras of people are multi-colored and rarely are just one color. However, there is a tendency for one particular color to dominate.

In form, the colors can be iridescent, misty, and soft. The aura can extend from two to three feet out from the body in straight lines or unfold like spirals. Others can appear as a halo or cloud above the head or as patches or specks of light surrounding the body. Your aura can be sensed by odor or heat and under the proper conditions can be seen with the naked eye. Your true character traits can be determined by the colors of your aura, your very own unique magnetic atmosphere. Animals, especially cats and dogs sense the aura of a person and respond accordingly.

HOW TO READ YOUR AURA

Anyone can develop the special visual sensitivity it requires to see auras, even your own. Fully extend your right arm above your head, your right palm facing the ceiling. Without blinking your eyes, fix your eyes on the tip of one of your fingers. Do not break your concentration, if you do, begin again. Continue to practice gazing intensely at one fixed spot. Eventually, you will see an emanation of light around your hand, while you gaze at the tip of your finger. It is very common to see the colors white, yellow, or blue at first. With more practice you will possibly begin to see multi-colors.

Once you've mastered this technique try to read your aura by standing in front of a mirror, preferably with a white or light and plain background behind you. Wear white clothing if you can. Now, focus at the top of your head. Practice this same technique with others, including animals, plants and inanimate objects. It's that simple.

COLORS OF BODY ENERGIES AND INDICATIONS

Pink - human love, refinement, aesthetic, modest
Salmon Pink - Universal Love, comfort, joy
Deep Pink - loving nature
Rose Red - deep love of family, patriotic
Red - strong desire
Red Flashes - anger
Bright Red - courage, hope.
Dark Red - ambition, vitality
Muddy or Cloudy Red - temper, restless
Orange Red - physically healing, revitalizing
Orange - ambition, pride, thoughtfulness, consideration
Yellow Orange - self-control, wisdom, spiritual
Brownish Orange - repression, laziness
Yellow - intellectual, positive disposition, optimistic
Lemon Yellow - artistic, mental agility, inventive
Golden Yellow - balanced mind and healthy body
Yellow with Red - inferiority complex, shy
Green - benevolence, abundance, peace, healing
Emerald Green - ingenuity, versatility, healing ability, trustworthy
Aqua - high ideals, peace, healing love
Light Delicate Green - compassion, sympathy
Grayish Yellow Green - shrewd, deceit, untruth
Blue- Violet - accomplishments through Divine power
Red-Violet - human will, physical power
Blue - healing love, spiritual understanding, inspiration
Light Blue - devotion to ideals, spiritual learning
Deep Blue - loyalty, honesty, unselfish dedication to causes or art
Indigo - Violet - spiritual seeker
Indigo (blue with tinge of purple) - excellent judgment, realistic
Lavender (pale purple) - humility
Orchid (tinge of pink) - spiritual, special, holy
Purple - spiritually practical, true greatness, unselfish efforts
Blue - Violet - accomplishments through Divine power
Red-Violet - human will, physical power
Blue - healing love, spiritual understanding, inspiration
Light Blue - devotion to ideals, spiritual learning
Deep Blue - loyalty, honesty, unselfish dedication to causes or art
Brownish Red - sensuality
Brown - industrious, orderly, effort, perseverance
Grayish Brown - selfishness
Greenish Brown - jealousy
Gray - fear, sorrow, grief
Silver - individualistic
Black Patches - hatred and malice
Black with Red - vicious, ruthless
Pearl White (opalescent) - gentleness, kindness, forgiving nature
Crystal White - spiritual self-mastery
Iridescent hues - highly spiritual

DIAGRAM OF COLOR ENERGY POINTS (CHAKRAS)

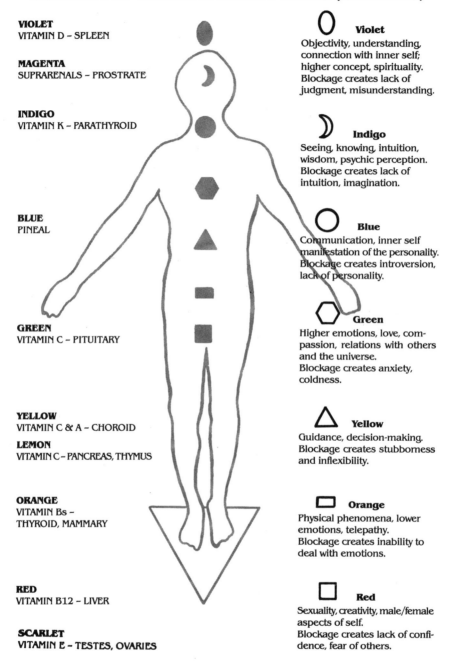

VIOLET
VITAMIN D – SPLEEN

MAGENTA
SUPRARENALS – PROSTRATE

INDIGO
VITAMIN K – PARATHYROID

BLUE
PINEAL

GREEN
VITAMIN C – PITUITARY

YELLOW
VITAMIN C & A – CHOROID

LEMON
VITAMIN C – PANCREAS, THYMUS

ORANGE
VITAMIN Bs –
THYROID, MAMMARY

RED
VITAMIN B12 – LIVER

SCARLET
VITAMIN E – TESTES, OVARIES

Violet
Objectivity, understanding, connection with inner self; higher concept, spirituality. Blockage creates lack of judgment, misunderstanding.

Indigo
Seeing, knowing, intuition, wisdom, psychic perception. Blockage creates lack of intuition, imagination.

Blue
Communication, inner self manifestation of the personality. Blockage creates introversion, lack of personality.

Green
Higher emotions, love, compassion, relations with others and the universe. Blockage creates anxiety, coldness.

Yellow
Guidance, decision-making. Blockage creates stubborness and inflexibility.

Orange
Physical phenomena, lower emotions, telepathy. Blockage creates inability to deal with emotions.

Red
Sexuality, creativity, male/female aspects of self. Blockage creates lack of confidence, fear of others.

APPENDIX

COLOR INTERPRETATION FOR YOUR RAINBOW JOURNEY

Page Number 10

Sunrise · Blue
High Noon · · · · · · · · · · · · · · · · · Yellow
Sunset · Red

Page Number 10

Winter · Indigo
Spring · Green
Summer · · · · · · · · · · · · · · · · · · Orange
Fall · Violet

Page Number 10

Circle · Blue
Square · Red
Triangle · · · · · · · · · · · · · · · · · · · Yellow
Oval · Violet
Rectangle · · · · · · · · · · · · · · · Orange
Hexagon · · · · · · · · · · · · · · · · · Green
Crescent · · · · · · · · · · · · · · · · · Indigo

Page Number 10

Horizontal · · · · · · · · · · · · · · · · · · Blue
Vertical · Red
Curved · · · · · · · · · · · · · · · · · · · Violet
Diagonal · · · · · · · · · · · · · · · · Orange
Jagged. · · · · · · · · · · · · · · · · · · Yellow
Checkmark · · · · · · · · · · · · · · · Green
Wavy · Indigo

ZODIAC SPECTRUM

The day you were born determines your zodiac sign. Each year the cusps of signs may vary slightly. If your birthday is on the cusp - begins on the first or last day for your sign, write *Maryanne* at **Star Visions** for the correct sign. **Star Visions** P.O. Box 39683 Solon, OH 44139

Aries... March 21 - April 20
Taurus.. April 21 - May 22
Gemini.. May 21 - June 21
Cancer... June 22 - July 23
Leo.. July 24 - August 23
Virgo... August 24 - Sept. 23
Libra... September 24 - October 23
Scorpio.. October 24 - November 22
Sagittarius.. November 23 - December 21
Capricorn... December 22 - January 20
Aquarius... January 21 - February 19
Pisces.. February 20 - March 20

BIBLIOGRAPHY

An extensive amount of research has been conducted through numerous workshops and teaching experiences of a wide and varied population over the past fifteen years. This rich array of information comprises the majority of the contents. The references listed below have been valuable resources that have guided and substantiated portions of this book.

Clark, Linda: *The Ancient Art of Color Therapy*, Pocket Books, New York, N. Y.

Birren, Faber: *Color in Your World*, Collier Books, New York, N.Y., 1978.

Birren, Faber: *Color Psychology and Color Therapy*, The Citadel Press, Secaucus, N. J., 1961

Bro, Harmon H., Ph.D., Ed.: Hugh Lynn Cayce, *Edgar Cayce on Dreams*, Warner Books, New York, N. Y., 1968

Heline, Corinne: *Color and Music in the New Age*, New Age Press, Inc. Los Angeles, CA., 1979

Hoffman, Maryanne: *The Goddess Guide*, Star Visions, Solon, Ohio, May 1990

Irion, J. Everett: *Vibrations*: Based on the Edgar Cayce Readings, A.R.E. Press, Virginia Beach, VA., 1979

Lewis, Roger: *Color and the Edgar Cayce Readings*, A.R.E. Press, Virginia Beach, VA., 1978

Luscher, Max, Ph. D.: *The Luscher Color Test*, Pocket Books, New York, N.Y.

Podolsky, Edward, M.D.: *How to Charm with Color*, Herald Publishing Co., New York, N. Y., 1943

Shelley, Violet: *Symbols and the Self*, A.R.E. Press, Virginia Beach, VA., 1979

SPECIAL PRODUCTS....

BOOKS autographed by

Maryanne Hoffman

The Goddess Guide

Poetic, sensitive and enlightening. Maryanne addresses the Goddess energy in both sexes and challenges you to change your life! Enriching techniques and positive guidance inspires you to heal, harmonize and handle yourself, your relationships and situations successfully. Featuring your Star-Sign Goddess personality, unique rebirthing technique, practical and spiritual meditations, important simple steps to reach your inner power and balance female/male relationships, power of gemstones and your personal power colors. $10

Personal Dream Diary

Create your own destiny through the power of your dreams! Learn how to use the phases of the moon, the cycles of the sun and the messages of color to interpret, record and recall your dreams. Features a moon and sun calendars, color chart and dream meditation mandala with complete interpretation. Illustrations, blank and lined pages. $8

The Rainbow in Your Life - $12

GREETING CARDS
Original Art by Maryanne

COLOR CARD SET - 8 full color designs of the color mandalas from the book *The Rainbow In Your Life*. With verse. - $15

ZODIAC SET - 12 different full color with metallic gold designs of each Zodiac Sign with verse or blank - $18

ZODIAC NOTE CARD SET - 12 cards of one Zodiac Sign - $18

ALL OCCASION FANTASY CARDS - 12 different whimsical designs in full color and clever, simple verse or blank - $18

GODDESS CREATIONS™ CLOTHING

*Designs
by Maryanne*

ARTWEAR FOR

A POSITIVE SELF-IMAGE

This exquisite design was especially created for you to enhance your beauty and to promote your personal power. Queen Nefertari is graced with the signature of Cleopatra. The hieroglyphic has a powerful universal message: "Illumine your path with love, beauty, health, peace and prosperity." Design is metallic silver and specially star-dusted hand-painted with iridescent glitter. One size fits all. Black, white, jade, purple, turquoise, and red. $39.00.
Hand - Dyed neon rainbow T-shirt. $47.00

COLOR MANDALA T-SHIRTS
(designs on back cover of book)

Mandala Colors & Designs - Red, Orange, Yellow, Green, Blue, Indigo, Violet, Magenta, Neutral Mandala (black or metallic silver).

BY *Maryanne Hoffman*

VIDEOS

The Rainbow In Your Life
A personal journey through the visual color meditations with an introduction to all the colors and their specific meaning. You will be color tested and learn how to read auras.

Color Therapy I
Color in everyday life with various special techniques on individual color testing and color applications. Hands-on instructional material that is required toward Color Therapy certification.

Color Therapy II
Hands-on Color Therapy techniques with special emphasis on color applications, integrated color testing. A continuation of Color Therapy I. Instructional material that is required toward Color Therapy certification.

Color Specialties
How to get the affect you want using color. A variety of color applications and important power colors for the individual and professions of all types. Simple Color testing included.

CASSETTES

The Rainbow In Your Life
Maryanne's soothing voice guides through the spectrum of your rainbow, as it applies to all the aspects of your life. For relaxation, motivation and health. Includes color health chart. 60 min. $12.95.

Visual Spectrum Meditations
Maryanne leads you through the images and essence of each spectrum illustrations from her book *The Rainbow In Your Life*. A richly fulfilling journey awaits you. $9.95. Cassette with book or with a set of 8 vivid **Color Cards** 51/2" X 7". $21.95.

The Astro*Guide Yearly Forecast
Maryanne's month to month predictions for your birth sign for the entire year. Detailed and specific forecast for money, love, career, family, travel, health, etc. $19.95. In booklet form $7.95.